50 FINDS FROM KENT

Jo Ahmet

AMBERLEY

First published 2021

Amberley Publishing
The Hill, Stroud
Gloucestershire, GL5 4EP

www.amberley-books.com

Copyright © Jo Ahmet, 2021

The right of Jo Ahmet to be identified as the
Author of this work has been asserted in accordance
with the Copyrights, Designs and Patents Act 1988.

ISBN 978 1 4456 9782 6 (print)
ISBN 978 1 4456 9783 3 (ebook)

British Library Cataloguing in Publication Data.
A catalogue record for this book is available from
the British Library.

Typeset in 10pt on 13pt Celeste.
SJmagic DESIGN SERVICES, India.
Printed in the UK.

Contents

Acknowledgements

First and foremost I would like to extend my sincere thanks to all the finders, those metal detectorists, mudlarks, field walkers and beach combers who record their finds. Without you this book and the Portable Antiquities Scheme would not be possible

A thank you also goes out to the metal detecting clubs that selected a find for this book. It was great to have you involved.

The PAS and the FLOs are a family and many of the fifty finds in this book were recorded by other FLOs. To them I'd like to say I am grateful for all your fantastic work, which has enabled me to write this book, and your support since I became a FLO in 2017. A special thanks to Katie Hinds and the late David Williams for their mentorship over the course of my work with the PAS. My predecessors Richard Hobbs, Michael Lewis, Andrew Richardson and Jennifer Jackson also deserve all the credit for establishing the scheme in Kent and creating a fantastic foundation on which I hope to continue to build.

My thanks should also be extended to my interns and volunteers over the years who have been instrumental in recording many of the finds on the database and some that ended up in this book, particularly Vikki Brereton, Andy Ward, Mags Erwin and Jane Clark.

Thank you to all the artists, Alan Marshall, Dominic Andrews and Edwin Wood, who have provided images to contextualise the finds in this book.

A big thank you to Naomi Humphreys for her mapping help, which has provided some great visual aids to show the distribution of the finds featured in this book.

I am grateful to the institutions, units and their staff who were able to provide images and assist with small pieces of research on archaeological objects, graves and in situ finds that are not always the easiest things to track down. Particularly thanks to Ges Moody at the Trust for Thanet Archaeology, Marit Gaimster at Pre-Construct Archaeology, Craig Bowen at Canterbury Museum, Pernille Richards at Maidstone Museum, Andrew Richardson at Canterbury Archaeological Trust, Jim Stevenson plus Fiona Grifffin at Archaeology South-East and finally the British Museum.

My thanks also to the Countess Sondes and the Lees Court Estate for the use of the portrait of Sir George Sondes, as well as Canterbury Museums and Craig Bowen for the use of Canterbury in the fifth-century reconstruction painting.

Unless stated all other images are courtesy of the Portable Antiquities Scheme or owned by the author. However, if we have inadvertently used copyrighted material without permission/acknowledgment we apologise, and we will make the necessary corrections at the first opportunity.

James Dilley's experimental archaeological work and the images it has provided for the understanding of prehistoric technology are fantastic and thanks for the use of this material.

To all those who have put up with me asking for comments or help in editing this book my sincere and total thanks to you: Imogen Harris, Gordon Hayward, Lindsey Ahmet, Dr Peter Reevil and Lis Dyson.

I would also like to extend my appreciation to my employer Kent County Council for hosting the FLO role in Kent and providing an excellent working environment and also for the use of images held in their archive. To my colleagues thank you for your support and patience with the writing of this book and the day-to-day running of the scheme.

Finally a big thank you to everyone I may have forgotten who has commented on an image, talked over a find with me or generally put up with me rambling about objects and shiny things.

Chapter 1
Introduction

In 1997, Kent was chosen as one of the first pilots for the British Museum's new Portable Antiquities Scheme (PAS). Proposed by Roger Bland (formerly of the British Museum) and modelled after a successful finds recording scheme based in Norfolk. This new voluntary recording programme was set up to provide a route to record stray archaeological objects found by members of the public. It was launched alongside the new Treasure Act, which came into force at the end of 1996, applying to England and Wales. The Treasure Act defines a number of object types that one is obligated to report to the coroner within fourteen days of discovery (see the treasure section of finds.org.uk for details). The PAS would thus also provide a mechanism by which qualifying objects can be easily reported.

Rolled out nationally in 2003, the scheme prioritised the recording of man-made objects dating to before 1700, regardless of material or how fragmentary they were. Once reported, these objects are recorded onto a publicly accessible database (finds.org.uk), with a photograph and at least a six-figure national grid reference. This latter point is important as it allows us to contextualise the finds, though as they can often be for sensitive sites they are not shown in detail on the public database. This work is carried out by a network of Finds Liaison Officers (FLOs) partnered with local heritage organisations, providing coverage for all of England and Wales.

Initially envisioned as working mostly with metal detectorists, the scheme has grown to now work with those searching river foreshores by eye (mudlarks), beach combers, fieldwalkers and even those who make chance discoveries while gardening or walking. Both the main groups of finders – metal detectorists and mudlarks – follow codes of conduct to protect in situ archaeology, sticking to areas of land disturbed by agricultural process such as ploughing or intertidal zones. Both groups are very passionate and, on the whole, supportive of recording their finds to contribute to our understanding of the past and help preserve the country's heritage.

At the time of writing (May 2020) the PAS database is nearing 1.5 million objects and, while each one tells their own story, uncovering the ways in which they fit together with the archaeology of the country has been very exciting. The database is proving a valuable tool for archaeologists, researchers and planners alike. Its data so far having been used in

more than 750 research projects ranging from school assignments through undergraduate and master's dissertations to PhDs. It also feeds into local council Historic Environment Records, providing links with council heritage departments and the commercial and community archaeological projects they support. This connection is particularly strong in Kent, with both the FLO and HER being based with Kent County Council's Heritage department.

Kent's archaeological past has long sparked passionate interest, as far back as the early antiquarians of the sixteenth century. They produced a wealth of early publications documenting their exploration of the county's past, the 1576 *A Perambulation of Kent* by William Lambarde being a notable early example. By the middle of the nineteenth century more formal study of the county's archaeology began with the founding of Kent Archaeology Society (KAS), which is still doing fascinating research. Since then, researchers, community and rescue archaeologists have carried out near-continuing programs of research exploring everything from the Saxon Shore Forts to the Thanet Barrow cemeteries. From the 1990s, this work has been supplemented by the discoveries of commercial archaeological units after the introduction of developer-led archaeology, with the Anglo-Saxon cemeteries at Saltwood and the Bronze Age boats at Dover being notable.

The dense archaeology of north and east Kent along with the river valleys of the Thames and Medway, apparently follow historic settlement patterns. The highly variable and contrasting geology and geography of the county must play a significant role in this. Geographically, Kent is the south-easternmost county in England and more isolated than it may first appear. It is hemmed in to the north and east by the sea, rivers to the north-west cut it off from London and Essex, and the Downland and High Weald are hilly, difficult terrain in the west, which separate Kent from Surrey and Sussex. Much of the underlying geography of this terrain is caused by the erosion of a chalk dome (the Wealden anticline) formed about 20 million years ago. This erosion left steep escarpments of chalk and greensand facing the Weald to the south, and a more gradual dip to the north.

The chalk downland, coastal zone and the Vale of Holmesdale have lighter and more productive soils, attracting settlement from the earliest periods. This contrast of harsh interiors and more (generally) fertile and populated coastal areas frequently saw Kent develop close ties to the continent as much as to the rest of England; whether this be via the prehistoric land bridge, which finally disappeared *c.* 9000–8000 BC or later maritime networks that would make the county wealthy and important.

Today Kent remains very mixed with heavy urbanism around Medway, the north coast and commuter towns such as Dartford and Tonbridge, contrasting with the very rural downland and the still often-forested Weald. Dover and Canterbury – historically important towns – remain large and populous, with Dover's port continuing to bustle with ferries and incoming trade.

Just south of the Medway estuary, Maidstone, the county town, continues to grow as part of the commuter belt, the distance between it and the Medway estuary conurbation of Strood, Rochester, Chatham and Gillingham shrinks year on year. While this reduces the

rural landscape available to metal detectorists and field walkers alike, increasing expansion has led to extensive archaeological work, often with successful collaboration between commercial archaeological units and detectorists.

The PAS has recorded finds from across the county, with almost every area and period represented, though most on the database, and indeed this book, come from the north and east of the county. This roughly fits what we know about settlement patterns in Kent, though a certain bias of where people go detecting should also be recognised. Particularly as historically populated and cultivated areas tend to have better transport links and are still, in many cases, heavily farmed making them ideal for metal detecting.

The finds in this book will hopefully give a good representation of this distribution and this was a consideration in selection. They are however only a selection and where possible one primarily concerned with presenting an overview of each period through a mixture of the typical everyday finds and those striking finds that grab headlines. We will look at metal, stone, ceramic and leather finds; with each having something different to tell us about the past and the people that inhabited it.

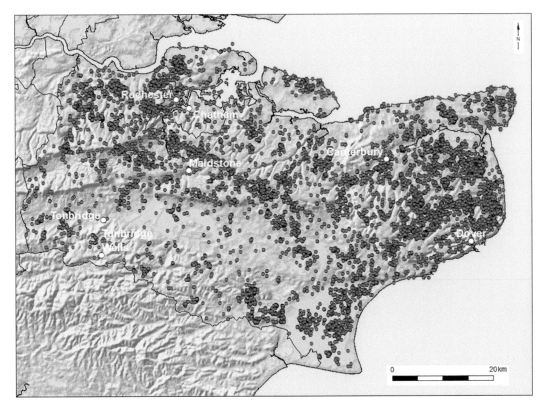

Figure 1.1: Distribution map of the PAS finds from Kent with the 50 finds discussed in this book shown in red, with the rest of the PAS find in blue. This is overlain on the topography of the county.

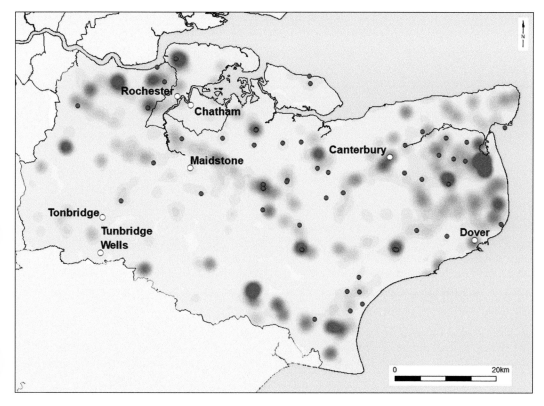

Figure 1.2: A heat density map of the finds recorded on the PAS from Kent. Strikingly, almost every part of the county has had something recorded from it, though the north and east retain the densest concentrations of finds.

Chapter 2
Stone Age Kent

The period of time we call the Stone Age is vast, and for ease it has divided into the Palaeolithic (old Stone Age), Mesolithic (middle Stone Age) and Neolithic (new Stone Age), which have in turn been subdivided again. The Palaeolithic dates from *c.* 800000 BC to *c.* 10000 BC. During this period ice ages come and go, as do various groups of human-related species (hominins) until modern humans appear *c.* 44000 BC. Hominins during this period

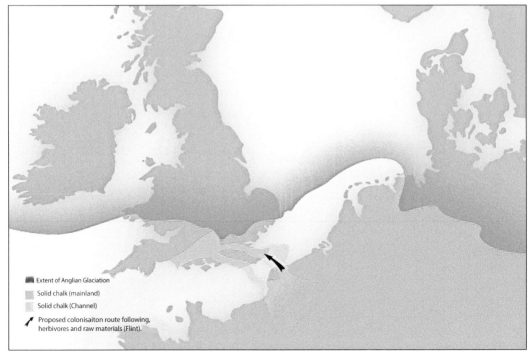

Extent of Anglian Glaciation
Solid chalk (mainland)
Solid chalk (Channel)
Proposed colonisaiton route following, herbivores and raw materials (Flint).

The extent of Palaeolithic ice sheets and migratory patterns (480000 to 425000 BC). (© Kent County Council)

had very mobile lifestyles meaning evidence is scarce, limited to scatterings of flint tools (mostly simple tools and handaxes for the first half of the period), with human and faunal remains mostly sealed under geological deposits. Despite this, and thanks to periods when it was connected to the continent by a land bridge, Kent has important evidence for the early settlement of Britain. Of particular note are Barnfield Pit, Swanscombe (which has the remains of early hominins including proto-Neanderthals), lots of lithics and faunal remains, and Southfleet Road, Ebbsfleet, where an elephant butchery site was discovered.

At the tail end of the Palaeolithic Britain is devoid of humans, being covered almost entirely in ice between *c.* 24000 BC and 13000 BC. When humans return *c.* 11000 BC, we see wide use of long flint blades which characterise this brief period before the start of Mesolithic *c.* 9000 BC. In the Mesolithic, small flint points called microliths become popular, evolving more geometric forms over time. This is radically different from their continental counterparts after around 8000 BC, when the straights of Calais form and Britain is severed from the continent. There is also widespread use of serrated scraping

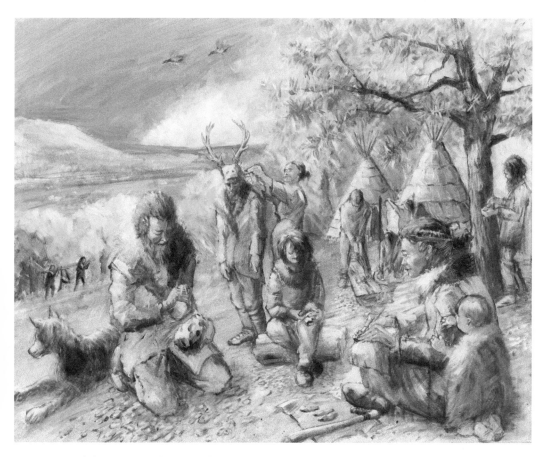

A Mesolithic camp and flint tool production. (© Alan Marshall)

tools and the adoption of hafted tools such as the tranchet axes. This shows a widespread use of wood, although no wooden objects survive from the county. Bone and antler are also used, as they had been from the middle Palaeolithic, but similarly to wood have yet to be found in Kent. Life for people seems to remain mobile, though some evidence of camps via hearths and flint scatters have been identified, with most activity seemingly taking place along river valleys.

The Neolithic, ending *c*. 2200 BC, is a major turning point for human settlement, with people transitioning from hunter-gather lifestyle to a more sedentary one. There is a gradual adoption of farming, woodland clearance for pastural grazing and construction of the first permanent settlements, such as the longhouse at White Horse Stone near Maidstone. We also see widespread construction of monuments, including henges, causewayed enclosures and long barrows. Of these, the most visible today are the long barrows of the Medway Megaliths group, built either side of the River Medway. Flint tool use continues to develop, with new tool types and techniques such as flint polishing being adopted. Trade and long-distant contact also seem to develop during this time, with axeheads from the Lake District, Wales, Cornwall and even the Alps all being found in Kent.

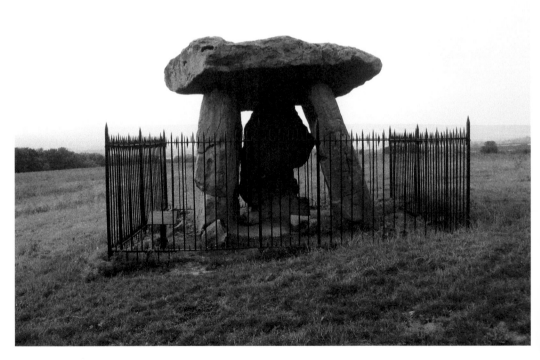

Kit's Coty, Aylesford, the dolmen or stones that formed the chamber of the long barrow. (© Kent County Council)

1. Flint ovate handaxe (KENT-3A6B67)
Lower to early-middle Palaeolithic (*c.* 500000–180000 BC)
Found near Ashford in 2017
79.55 mm long

Of all flint tools it is perhaps the handaxe which is most iconic, being easily identifiable. They are not an uncommon find from Kent, often being found by quarry workers and coastal walkers after cliff falls. They are perhaps the longest-used type of tool in human history, though they do not appear to have been used by anatomically modern humans in Eurasia. Most are core-formed tools, whereby a single flint nodule is shaped by the removal of flakes until it has the desired shape.

The example here is quite battered but shows an interesting pattern to its flaking as the person making it has gently rotated it while removing flakes, which has left it with a slight uneven and 'twisted' profile. This profile isn't a particularly common trait, though a number of similar examples were recovered from Rickson's Pit and Person's Pit near Dartford, northern Kent. Part of the Acheulian flint industry, *c.* 500000–180000 BC, of which the pear or 'cordate' shaped axes are particularly representative, these 'twisted' handaxes from the Dartford pits have a narrower date, appearing to be confined to the latter end of the industry's presence in Britain.

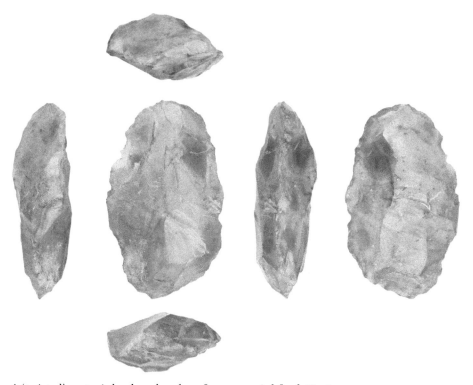

A 'twisted' ovate Acheulean handaxe from near Ashford, Kent.

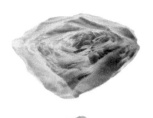

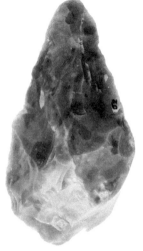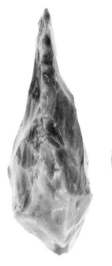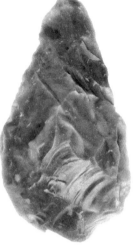

Above: A cordate Acheulean handaxe of iconic shape found between Herne and Westgate-on-Sea (KENT-C3645E).

Left: The shaping of a Palaeolithic style handaxe suggested by experimental archaeology. (© AncientCraft – James Dilley)

2. Possible Mousterian flint point (KENT-C04728)
Later middle Palaeolithic (*c.* 60000–40000 BC)
Found in Preston in 2018
59.94 mm long

Although handaxes were long-lived, the most common method of lithic tool production involved striking a flake from a larger piece of stone called a core. In most cases this new flake was then further modified with flaking and finer work – called retouch – to produce the final tool. A less common technique known as Levallois involved the preparation of a core, shaping the tool on the core and then striking it away once it was ready. Both techniques leave distinct features on the object, with flaking, a bulb and ripples within the flint surface often visible (see diagram). The Levallois tools also tend towards flat unworked undersides (ventral sides) and less retouch.

The Levallois technique appears to have been used to produce this object. A flint point, probably for a spear, with the distinctive shape associating it with the Mousterian flint industry adopted by Neanderthals in Europe. This point appears to have had a quite long use life with retouch added to re-edge or reshape the tool. This is unusual for such points as retouch isn't as common on Levallois tools as other flaked tools or core-formed tools.

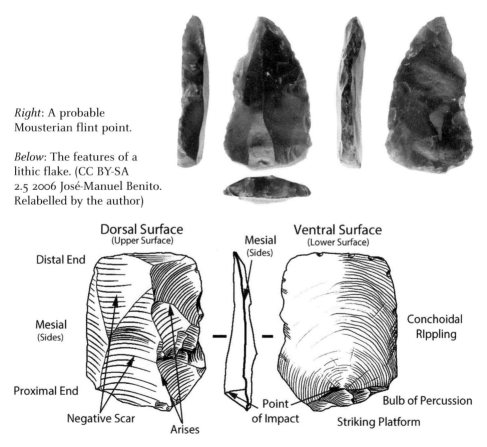

Right: A probable Mousterian flint point.

Below: The features of a lithic flake. (CC BY-SA 2.5 2006 José-Manuel Benito. Relabelled by the author)

Dorsal Surface
(Upper Surface)

Mesial
(Sides)

Ventral Surface
(Lower Surface)

Distal End

Mesial
(Sides)

Conchoidal
RIppling

Proximal End

Negative Scar

Arises

Point of Impact

Striking Platform

Bulb of Percussion

This small flint blade is a microlith, small flaked tools popular during the Mesolithic. It is unfortunately broken along its upper edge but would have had an obliquely blunted point. Part of the abrupt retouch is visible on the left side of the dorsal (upper side) of the blade just before the break. This example fits the early 'A group' of microliths: around 40 mm long and dating to *c.* 9000–8000 BC – later examples tend to be tiny, with much more extensive retouch. The cores produced during their production are easily identifiable, being either cylindrical or conical with flakes removed parallel to each other. They can be very small, with some seeming to have been favoured and remained in use for some time.

Microliths were used in various ways; some such as this example may have been used as tools in their own right, while other were set into hafts, and a recent group found in Sweden were set in a wooden shaft with resin to be used as a projectile. Because of their ubiquity during the period where one is found, more will likely be found in vast quantities, along with the detritus of their production.

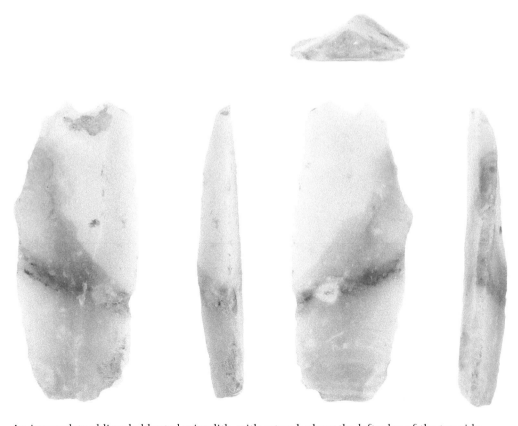

An incomplete obliquely blunted microlith, with retouch along the left edge of the top side.

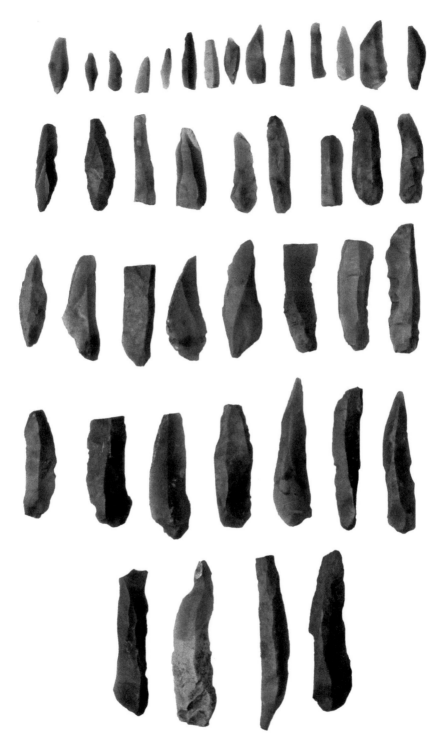

A selection of more than 200 microliths and waste flakes discovered in one small area of Newbury, West Berkshire. Assemblages of this size from temporary camps dating to the Mesolithic are not uncommon. They really show how prolific peoples of the period could be with their production of tools (OXON-AB9254)

While handaxes may have fallen out of fashion, we see the development of hafted axes during the Mesolithic. These mostly fall into two very similar types: tranchet axes and the so-called 'Thames picks'. Both are core-formed tools roughly flaked with a very neat single sharpening 'tranchet' flake parallel to the cutting edge that finishes the blade. Thames picks tend to be cruder than standard tranchet axeheads and retain cortex – the hardened, rough outer surface of natural flint.

This particularly example is very finely made and is slightly waisted to facilitate attachment to a haft. The attractive banding in this flint is a formed from a vein of poor-quality chert or low-silicate flint. This would have been a weak point in the flint, possibly leading it to break in use. An experienced flint knapper, as the maker of this tool clearly was, would have known this and chose it despite this, perhaps valuing the flint's aesthetic properties over this weakness.

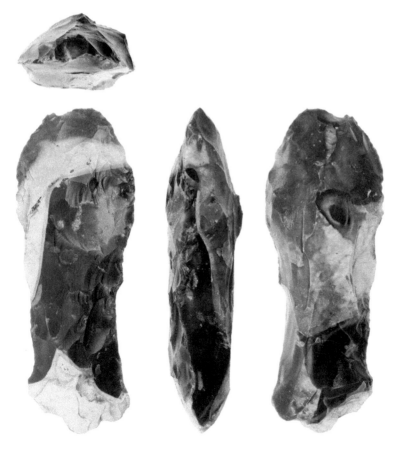

A tranchet axehead. Note the attractive banding and the parallel flake most clearly visible on the side view.

5. Polished axehead (KENT-661CF8)
Neolithic to early Bronze Age (*c.* 4000-2200 BC)
Found near Sturry in 2013
116 mm long

During the Neolithic a new method of flint finishing was developed, wherein in tools were shaped with flaking and then heavily polished with an abrasive stone such as sandstone. This appears to have been done for almost entirely aesthetic reasons as it does not hugely improve the cutting edge of the axe; indeed, there are examples where a new edge has been added and never repolished. Like the Mesolithic tranchet axes, these tools would have been hafted, with a number of amazing examples from Scandinavian bogs retaining their wooden handles.

These axes date from a time when woodland clearance was accelerating to create land suitable for pastoral and arable activities newly adopted during the Neolithic. This clearance, and the creation of houses and monuments for which wood was a significant component, would make good-quality axes like these vital.

The shape of these axes is striking and easily identifiable. It is therefore easy to recognise this shape among the earliest metal copper flat axes of the beginning of the Bronze Age. It may also have been the case that the polishing technique employed on the flint was adopted for the new material leading to the discovery of metal sharpening.

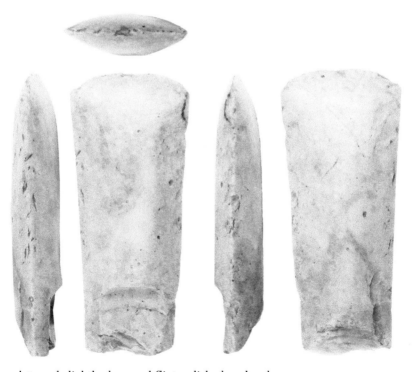

An incomplete and slightly damaged flint polished axehead.

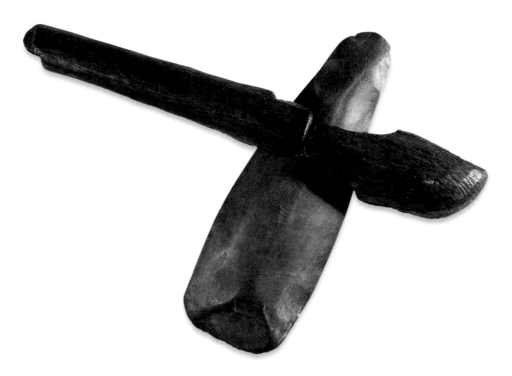

A polished axehead with its decayed wooden handle from Ehenside Tarn, Cumbria, now in the collection of the British Museum. (© The Trustees of the British Museum)

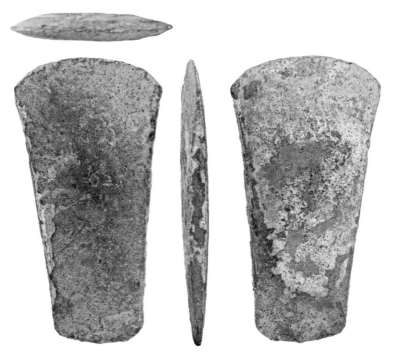

A copper Halberton type/Needham type 2D flat axehead dating to the transition of the Neolithic to early Bronze Age, *c.* 2400–2200 BC. Found near Ashford (KENT-D7B811).

6. Rounded scraper (KENT-B8882D)
Late Neolithic to early Bronze Age (*c.* 3300–1000 BC)
Found near Lyminge in 2017
38.65 mm long

Most of the flint tools up to this point have been fairly clear in their dating, albeit it in some cases over vast periods of time. Many flint tools are, however, ubiquitous, and without good stratigraphic context it can be difficult to place them. Thus, wide dates and the balance of probability are important aspects in the recording and identification of such tools.

This round flint scraper is one such tool, probably dating from the later Neolithic to early Bronze Age. However, round scrapers were used in preceding periods and the identification is based on findspot, probability and its preservation. This ambiguity on dating such an out-of-context objects is common among scrapers as they are widely used tools important, for animal processing and wood-working. This isn't to say all scrapers are difficult to date; the small thumbnail scrapers of the Neolithic Bronze Age transition are very distinct.

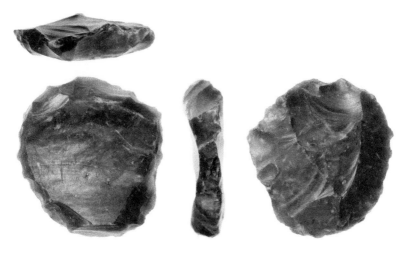

A round scraper of late Neolithic or early Bronze Age in date.

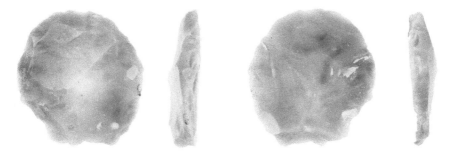

A very fine small 'thumb-nail' scraper dating to the Bronze Age/Neolithic transition, *c.* 2400–2200 BC, found in Aldington (KENT-206557). Note how thin it is and the presence of a slight projecting rectangular butt at the bottom end, consistent with the type.

Chapter 3
Bronze Age Kent

It can often seem like the transition from the Neolithic to Bronze Age happened over night, but a transition period from *c.* 2400–2100 BC is now widely accepted. Sometimes referred to as the Chalcolithic (Copper Age) or Beaker Period, it is marked by the sparse, gradual adoption of copper, rare use of gold objects and a widespread adoption of ceramic handmade bell-shaped beakers. The use of these beakers is common through much of western Europe and is often accompanied in Kent by a new practice of crouched burials under a small barrow. Grave goods included the eponymous beakers and other objects such as copper daggers, flint arrowheads and jet ornaments.

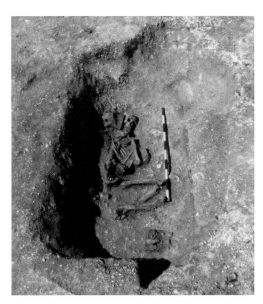

Above left: 'Primary beaker burial accompanied beaker vessel and arrow heads (1902 (+/- 33) BC). Margate, Isle of Thanet, 2005.' (© Trust For Thanet Archaeology).

Above right: A casting of an early copper axehead using contemporary methods. (© AncientCraft – James Dilley)

For the rest of the early Bronze Age up to *c.* 1500 BC, barrow burials continue, although the beaker-style inhumation do not remain in use. Burials beneath round 'bowl-shaped' barrows continue in Kent until the end of the early Bronze Age (*c.* 1500 BC), although the fashion for beakers placed in the graves dies out around *c.* 1900–1700 BC. Due to the agricultural use of much of the county barrows do not survive well - especially when compared to other chalk downland counties such as Wiltshire and Hampshire. The use of copper – now often alloyed with tin to produce bronze – becomes more common, with axes becoming ever more specialised. During this period, we also see metal artefacts being hoarded (collected together in groups), although this practice remains relatively rare. Some of the hoards appear to contain objects that have been partially broken possibly with the intent to put them beyond use.

From the middle Bronze Age, barrows become rarer but more varied in construction, with new types developing, such as the bell barrow at Mutton Wood in the Medway Valley area. Settlement evidence becomes far more visible with the communities building roundhouses and enclosures. Cremation is also adopted during this period, often in large pots, which are sometimes inserted into earlier barrows. At the same time, we see a vast expansion in the use of copper alloy and gold, and an evolution of axe types. We also see an explosion of hoarding during this period. Much of this continues into the end of the Bronze Age and beginning of the Iron Age. Burial evidence is a notable exception for the end of the period being so diffuse in the archaeological record that there is no recognisable burial practice in Kent from the Late bronze Age to the early Iron Age.

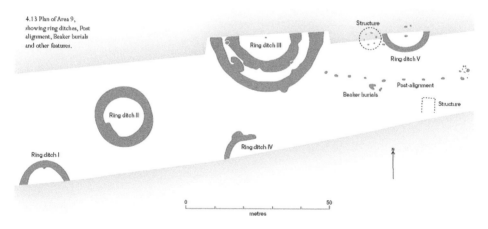

4.13 Plan of Area 9, showing ring ditches, Post alignment, Beaker burials and other features.

Plan of the Monkton barrow cemetery with ring ditches from barrows and beaker burials visible. (© Kent County Council)

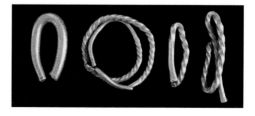

Middle Bronze Age gold torcs from the River Medway at Aylesford in 1861, now in Maidstone Museum. Left to right: bar torc with round section and engraved grooving to imitate twisted types; a complete twisted torc and two similar fragments broken in antiquity (© 2020 Kent County Council).

7. Gold disc (KENT-5C3F42)
Early Bronze Age (*c.* 2450–2150 BC)
Found near Cobham in 2004
27.2 mm in diameter

This sheet metal gold disc has five engraved broadly concentric decorative circles and is pierced by two holes. The decoration has been created using a fine engraving tool and a series of central punched marks are also present. The disc may have been deliberately folded, a practice seen in other sheet metal gold artefact and may have been further damaged by movement in the ground. Often called sun discs, these objects are usually thought to come from graves where they were attached to clothes or used as decorative fastenings. Despite being rare they have a wide distribution across Britain.

These objects date to the chalcolithic/beaker period and are some of the earliest metal objects found in the country. Similar sheet metal gold objects like lunula were initially produced from naturally occurring metallic gold, which is then hammered out. Sheet gold objects remain popular throughout the Bronze Age, with cast gold objects occurring from the middle Bronze Age. Interestingly we see imitation back and forth among sheet metal and cast objects suggesting both techniques were in practice at the same time.

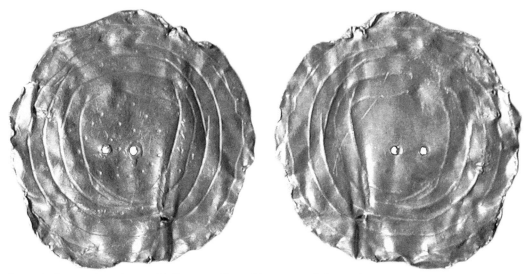

An early Bronze Age sheet gold disc, sun disc with engraved decoration.

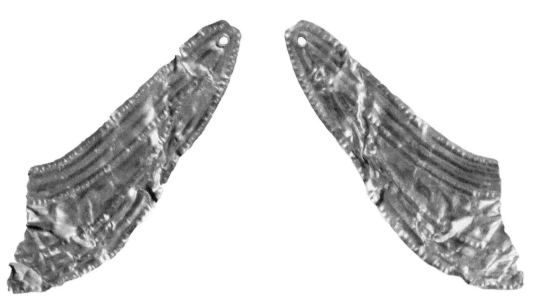

A similarly dated (*c.* 2350–1800 BC) fragment of sheet gold lunate like object or foil diadem found near Stowting in 2017 (KENT-897021).

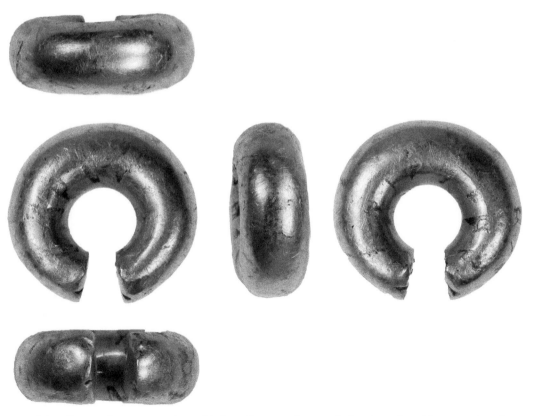

A late Bronze Age penannular gold ring of a type often copied and produced by wrapping sheet gold round a solid core. Found near Meopham in 2018 (KENT-FF00A6).

8. Jet or shale necklace terminal (KENT-A5B841)
Early Bronze Age (c. 2050–1800 BC)
Found near Maidstone in 2010 and selected by Jen Jackson, former Kent FLO
44.7 mm long

This large jet bead is the spacer/terminal of an elaborate necklace. The necklace would have been formed from many shale or jet beads and are mostly known from burial contexts. Its intricate incised surface decoration and fixings have all been carefully executed with skill. The back remains undecorated and there is some light damage.

This bead appears to be the only known example of this type from south-east England. They are mostly seen as a northern and westerly phenomenon; with the closest known examples being found in East Anglia and Wiltshire. The arrangement of spacer bead ornaments appears to copy that of Irish gold lineal ornaments in their crescent shape.

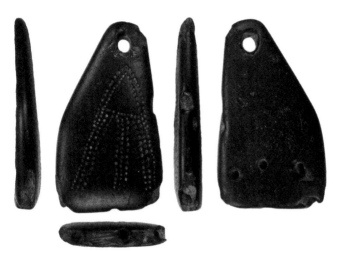

Left: An early Bronze Age jet or shale bead spacer or terminal bead.

Below: A complete early Bronze Age jet or shale necklace of a similar type to the Maidstone example, found in Ross-shire in Scotland. (CC-0 1896 Archceoiogia, XL, p.505., Figs. 198, 199)

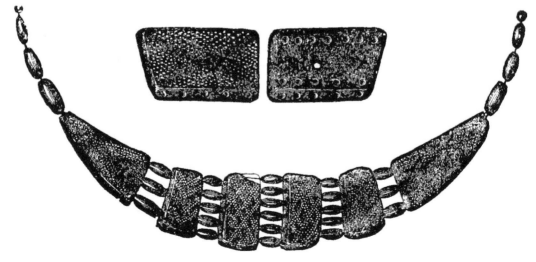

9. Barbed and tanged flint arrowhead (KENT-D54A09
Bronze Age (*c.* 2200–1000 BC)
Found near Cliffe on the Hoo peninsula
30.1 mm long

Arrows and, by extension, bows have been present in Britain since humans returned after the last Ice Age, though it wasn't until the Bronze Age that they evolved into the iconic pieces of flintwork we recognise today. Barbed and tanged arrowheads like this example have been used by various cultures across the world and throughout history, being relied on as the primary hunting tool and projectile weapon. The barbs are designed to hook into their targets, and are a technological breakthrough facilitated by the technique used in their production.

As with most northern European examples, it was produced via pressure flaking, which is where very small flakes are removed with specific targeted pressure applied by a point formed of bronze, bone or antler. These arrowheads were the product of highly skilled artisans, and it is ironic that this peak of flint workmanship occurred during a period of time when flint was being superseded by metal.

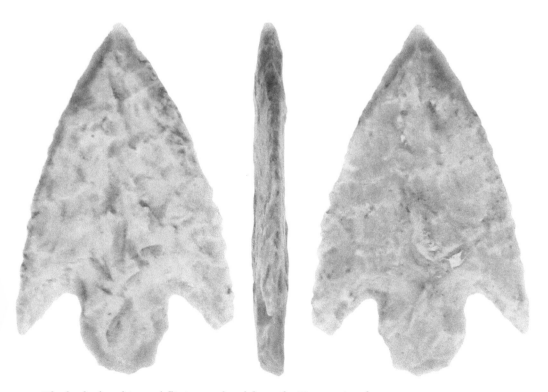

The barbed and tanged flint arrowhead from the Hoo peninsula.

Left: A Neolithic arrowhead of an earlier ogival type. It shows the use of pressure flaking to enhance the already skilled flaking and retouch in use during the Neolithic period. Found near Midhurst, West Sussex, in October 2016 (KENT-9E2587).

Below: A copper-alloy Bronze Age arrowhead from Bradenham in Norfolk. The date of such copper-alloy arrowheads is not yet certain, as they are very rare particularly in sealed archaeological contexts, though they do seem to mirror the styles of those executed in flint from which dating is derived. Found in Norfolk in 2018 (NMS-DDFF5A).

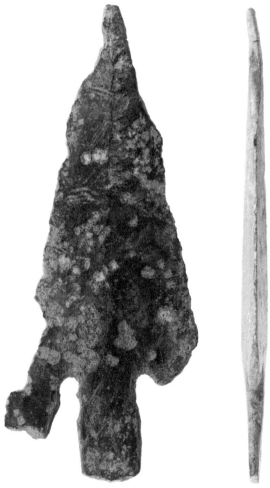
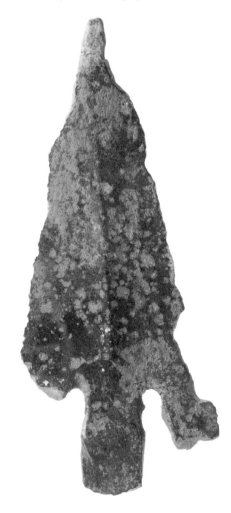

10. Gold cup (PAS-BE40C2)
Early Bronze Age (c. 1700–1500 BC)
Found near Ringlemere in 2001 and selected for inclusion by Michael Lewis
 former Kent FLO
112 mm high

The Ringlemere Cup is perhaps the most famous archaeological object from Kent and has taken pride of place in many an exhibition. The cup was created from hammered sheet gold and has a strip handle applied via rivets. It has been crushed due to repeated periods of plough striking over the centuries. This process also likely dislodged from where it was placed in a vast 150 m diameter barrow subsequently discovered during archaeological investigation of the site.

The cup fits a varied, though small, group of loosely connected 'precious' cups found primarily along the channel coasts of England, Brittainy and the Rhineland, though it is likely we may be missing examples along the rest of the European channel coast. These cups seem very similar to the ceramic beakers of the preceding period but are contextually later. They are made of various rare materials, such as gold, silver, high-quality shale and even amber.

The cups tend to be grouped by a suite of features, but no single cup exhibits all of them. The fairly common traits of corrugation/grooving, round bottom and a single handle are seen on the Ringlemere Cup, although its flared mouth and shouldered body are unusual, these features perhaps being seen on one other of the 'precious' cups. Of the known examples in the group, Ringlemere is the tallest and one of the heaviest. With its features and size taken together, it is most similar to the Rillaton Gold Cup from Cornwall. While Ringlemere may simply be one of this group, it remains a striking snapshot of the interconnected world of Bronze Age Kent.

The Ringlemere Gold early Bronze Age cup. Note the distinctive rivets for the handle and the lightly drilled decoration around the rim.

11. Hoard of palstave axeheads (KENT-FC6918)
Middle Bronze Age (*c.* 1400–1250 BC)
Found near Otterden in 2017

Hoarding becomes particularly prominent from the middle Bronze Age and Kent has produced a significant number of hoards, both of middle Bronze Age (77) and late Bronze Age (83). This particular hoard is made up of eighteen palstave-type axeheads, identifiable by their distinctive raised and fused hafting arrangement, rectangular waists and flanged bodies, with broad cutting blades. They are dated more narrowly to *c.* 1400–1250 BC known as the Taunton Phase, so-named after the typesite at Taunton Workhouse. Somerset.

Hoards such as these sometimes survive in situ (undisturbed), so, where possible, excavation can be vital to recover the whole picture of how the artefacts were placed in the ground millennia before. This example was particularly interesting as the upper section of the hoard was originally disturbed by First World War military huts. The axeheads were

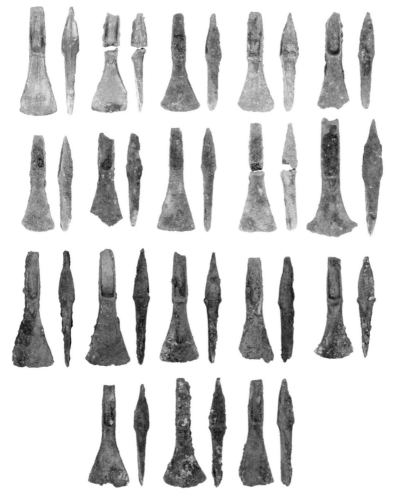

The Hall Place palstave hoard found in Otterden during 2017.
It shows, despite varying states of preservation and mud coverage, similar features among some of the axehead.

deposited in layers laid butt to blade, and, while superficially similar in form, the group vary in detail, use and finishing, suggesting they were collected from different 'sources' and may not have all shared the same life histories. Exactly why hoards like this are buried is still debated by archaeologists and in reality, the practice is likely governed by a myriad of interconnected influences from economic to ritual.

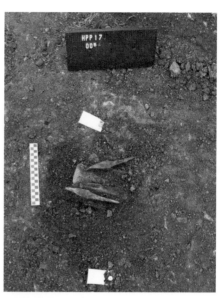

Right: The Hall Place palstave hoard in situ, showing slight disturbance to the upper visible layer by the First World War ditch (running along the left of the image). The layer below is undisturbed with the axheads laying butt to blade.

Below: The Crundale Hoard, a so-called founders hoard dating to the late Bronze Age or early Iron Age. It consists of a mixture of broken objects (including some fragments of middle Bronze Age palstaves), casting waste, ingot fragments and some complete late Bronze Age socketed axeheads. Found near Crundale in 2003 (KENT-7C3863).

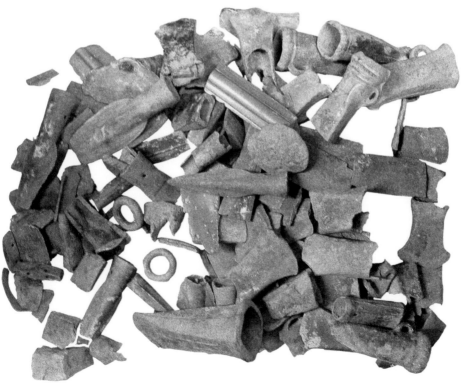

12. Socketed chisel (KENT-9E799c)
Late Bronze Age to early Iron Age (*c.* 900–700 BC)
Found near Lenham in 2017
53.08 mm long

During the late Bronze Age we see the development of socketed tools, primarily axeheads but also other woodworking groups – such as this rare socketed chisels. This example has a thin, tubular body, narrowing towards the centre with a slightly flaring socket and a narrow crescentic blade. Due to the good preservation, it is possible to see fine incised decoration consisting of a ring of short herringbone lines around its body and a line of similar decoration along each face and side. The decoration is particularly distinctive, and not something usually seen on Late Bronze Age metalwork. Where it is seen, however, is on some examples of early Iron Age Sompting type socketed axeheads. It is also arguably much more finely executed than other bronze socketed chisels. This likely marks it as a product of the Bronze Age/Iron Age transition.

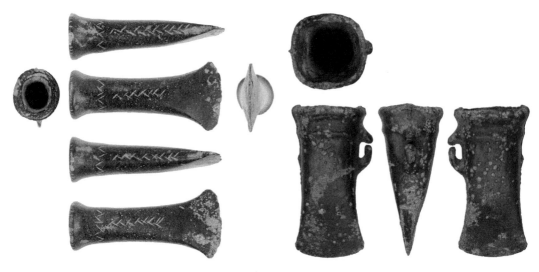

Above left: A late Bronze Age to early Iron Age socketed chisel. Note the fine decoration and well-executed blade.

Above right: A late Bronze Age to early Iron Age socketed axehead, typical of the period, found near Ashford in 2010 (KENT-2126A8).

Chapter 4
Iron Age Kent

The beginning and the middle of the Iron Age is difficult to easily define. Evidence is sparse, with settlement being relatively difficult to identify outside of east and north-east Kent. What is found is often limited to small farmsteads through to occasional larger settlements, which are large groups of roundhouses and small enclosures. The large multi-enclosed settlements common in other counties are rare in Kent. Hill forts and the large settlements referred to by Julius Caesar as *oppida*, which are elsewhere common features of the British Iron Age, are relatively rare and appear late in the middle Iron Age

The now wooded defensive ditches of Oldbury hill fort, one of the largest such sites in the country. (© Kent County Council)

to late Iron Age, with only Bigberry and Oldbury hill forts being of note. Burial, as at the end of the Bronze Age, continues to be illusive. What is known moves from crouched internments to those laid face up by the middle of the Iron Age, with the occasional use of cremation in both periods.

Artefacts of this period are also uncommon. Iron, despite defining the period by its use, remains relatively poorly represented until the later Iron Age. However, Kent's earliest evidence for ironworking such as from South Street, Herne Bay and tools found at White Horse Stone are some of the earliest for Britain. Copper alloys remain in use but are rare too after the Bronze Age to early Iron Age transition. Ceramics become the most easily identifiable piece of artefact evidence from the period, with clear links in the east of the county to the Continent. This is seen in a shared fashion of rusticated surfaces and decorated fine wares. These close links are further supported by a group of bone combs found either side of the channel.

By the later Iron Age we begin to see the widespread adoption of cremation, some of which are deposited in large bronze and wooden buckets, and included among a suite of

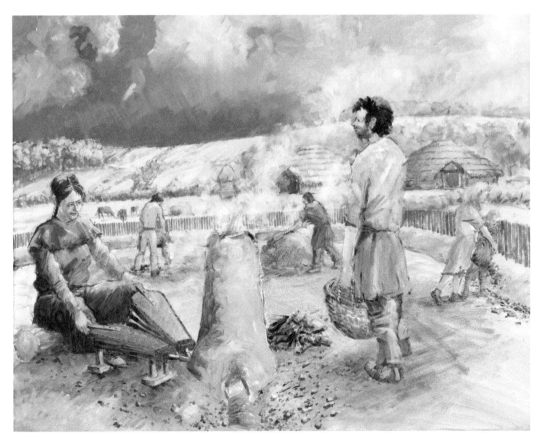

Reconstruction of an Iron Age settlement with round houses, a four post structure, and enclosure for industrial activity. (© Alan Marshall)

other grave goods. There is also sporadic inhumation burial, some of which are termed 'warrior burials' since they include spears and swords, such as at Brisley Farm near Ashford or the famous Mill Hill warrior, who also had a bronze crown decorated in distinctive Iron Age style.

More metallic objects occur during this later period, ranging from sword, horse and cart fittings to decorative jewellery and brooches. Many of these show influences of continental design and artistic style. Coinage also comes initially via the Continent, with local imitation appearing soon after. By the end of the Iron Age there is a vibrant and varied monetary economy consisting of gold, silver and bronze coins. Links to the Continent further develop with imported ceramics and the adoption of the potter's wheel, leading to a far more varied ceramic corpus in the two centuries before the Roman conquest. We also see the growing influence of Rome, with imported goods, coins and ideas all influencing the development of art of the material culture of late Iron Age Kent.

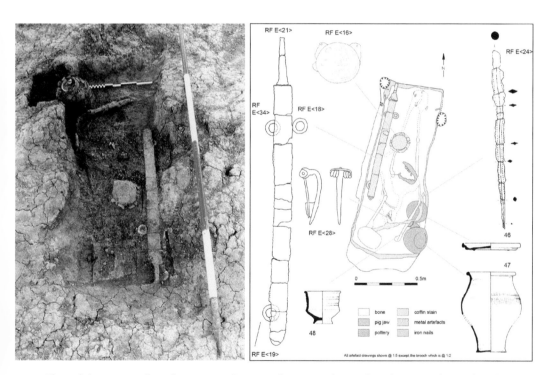

Plan of the warrior burial, grave 19, from Brisley Farm. (© Archaeology South-East/UCL)

13. Copper-alloy brooch (KENT-3A6B67)
Middle Iron Age (*c.* 450–250)
Found near Higham in 2017
47.33 mm long

One of the first relatively common groups of Iron Age metallic objects are brooches, which are quite large, chunky, bow brooches or fibula. This example has many features that bow brooches will retain until near the end of the first millennium AD: an arched bow, an integrally cast catch plate at the foot, and a spring (or later a hinge) at the head (although missing on this example). It has cast decoration consisting of relief ribs dividing the bow into square panels. Such brooches date from the fifth to fourth century BC and are a product of the first period of the La Tène cultural phenomena that spanned northern and areas of central Europe from the middle Iron Age until the Roman conquests. Over time, such brooches evolve into many new types. They become such a integral part of Iron Age British material culture that their use continues during the Roman period with little overall change in form.

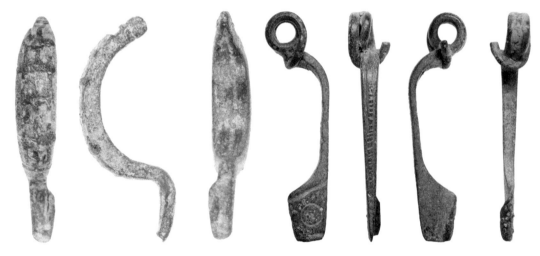

Above left: A La Tène I style bow brooch showing unusual decoration and solid foot with cast and hammered out catch plate for the now missing pin.

Above right: An incomplete cast copper-alloy Iron Age La Tène III style (Nauheim derivative) brooch dating to the first century AD. One of a number of permutations of the late Iron Age brooches in use in Britain on the eve of the Roman conquest. Found Near Lenham (KENT-492C3F).

14. Copper-alloy potin coin (KENT-7CFED2)
Late Iron Age (*c.* 175–100)
Found near Lyminge in 2017
18.94 mm in diameter

A defining feature of the late Iron Age is the adoption of coinage, initially via imported Gallic gold coins based on Greek prototypes from the second half of the third century BC. This was soon followed by silver coinage of the Roman Republic. In both cases these seem to be relatively sparse, likely circulating, at least to start with, as bullion. More significant was the introduction of copper-alloy coins from the southern Greco-Gallic city of Marseille. Such coins were widely copied, often crudely in Gaul, with similar copies soon produced by Cantiaci tribe in what is now Kent.

This example displays the helmeted head of the Greek god Apollo on one side and the other a butting bull under the initials of Marseille, 'MA'. The earliest of these cast copper units, or 'potins,' are called the Thurrock type, after the Thurrock hoard. Over time the designs evolve to become the abstract flat linear potins that define the coin's features, with lines rather than the solid portraiture of the earlier issues. Both types are cast in long strips and then snapped off, often leaving them with significant casting seams and elements of sprue attached. These coins are incredibly common in Kent compared to the rest of the country, occurring as hoard, stray and site finds. Such is their proliferation in the territory of the Cantiaci, it seems likely that these coins circulated here as more than bullion and served as part of some sort of monetary economy.

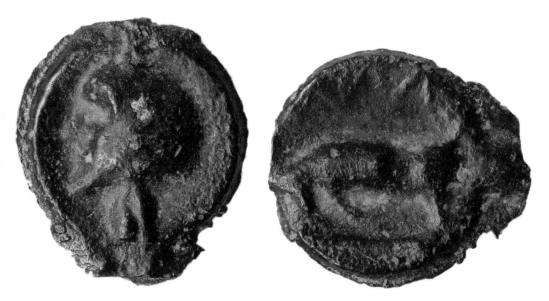

Cast copper-alloy bronze unit or potin of Thurrock type dating *c.* 175–100 BC. Note the clearly defined butting bull with the MA above as well as significant casting flash and sprue.

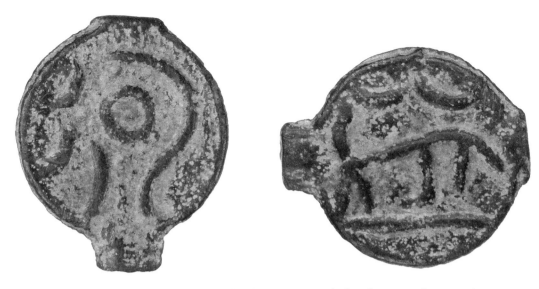

Cast copper-alloy bronze unit or potin of flat linear type. Both the obverse and reverse design have devolved into mere outlines of the intended motifs (KENT-FFCC96).

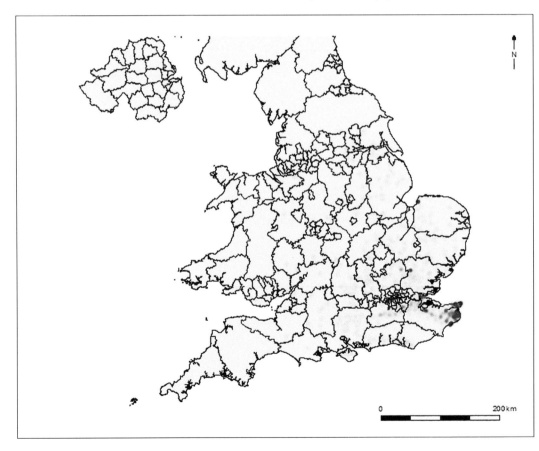

A heat density map of the distribution of single potin and hoard finds in Britain recorded with the PAS, showing clearly defined concentrations in north and east Kent.

15. Copper-alloy coin die (KENT-2EEAF0)
Late Iron Age (c.150–100 BC)
Found near Bredgar in 2013
29.5 mm long

While the potin coinage was cast, the majority of Iron Age coinage, and indeed the coinage of subsequent eras until the late seventeenth century, was struck. This is a process whereby a disc of metal is place between two dies that correspond to the obverse (front) and reverse (back) of the coin; the upper die is then struck with a hammer to stamp the image on each side of the coin. The dies to strike coins are very rare, often wearing out and being recycled or intentional destroyed to prevent their further use. This find was therefore very surprising, a coin die for the reverse of some of the earliest coins in Britain.

The die appears to be for a type of gold coin called a stater. These were based on Greek prototypes of Phillip of Macedon and produced in Gaul, known as the Gallo-Belgic A series. These coins were thought to be produced in Gaul and imported into Britain – could this die mean that such coins were being produced here rather than the Continent? The answer is unclear, particularly as this coin die doesn't match any of the 250 or so Gallo-Belgic A staters known from Britain, France or Belgium. This has led to speculation that the die was made to copy this series of coins.

Right: This die or punch is for a Gallo-Belgic series A gold state. It has been finely engraved with the design having taken very little wear, possibly indicating it never struck coins.

Below: A Gallo-Belgic series A gold stater attributed to the Bellovaci tribe, from what is now modern-day Picardy, France. Found near Smeeth in 2017 (KENT-52ABB3).

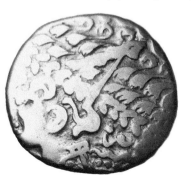

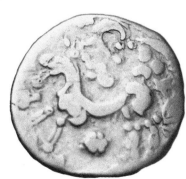

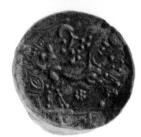

16. Copper-alloy and iron linchpin (KENT-4CB117)
Late Iron Age (c. 100 BC–100 AD)
Found near Aylesham in 2018
124.8 mm long

In Caesar's accounts of the Britons and the later writings of the Boudican rebellion, we hear that the indigenous people utilised chariots in war, a practice long-since abandoned on the Continent. Kent lacks the chariot burials known from northern England, southern Scotland or even Pembrokeshire, Wales, but every so often we get hints of these fearsome vehicles. These mostly come through fittings and fixtures for chariots, such as terret rings used to guide the reins along the shaft or objects like this – linchpins.

Linchpins are fittings designed to slot in the end of an axel and hold the wheel in position, and so would have been vital in cart or chariot construction. This is a particularly fine example remains in good condition. It is very elaborate, with large bronze decorative terminals, the upper with a striking crescentic shape. The use of such terminals is a feature of the late Iron Age, with Roman examples forgoing them. The decoration is all cast in relief, with some enhancement through finishing. Much of the decoration is imitative of cordage, particularly noticeable around the collars, which are places where such actual ropes would be used to bind the linchpin to the axel.

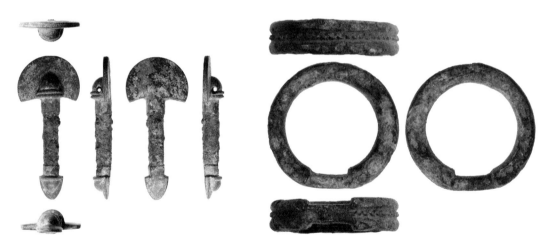

Above left: Iron and copper-alloy linchpin. Although the cordage-style decoration is prominent, we can see further decoration on the border of the lower fitting and around the upper edge of the crescentic headplate.

Above right: A late Iron Age miniature terret ring dating to *c.* 150 BC to AD 100. With similar decoration, albeit more crudely executed. Not the slightly recessed bar at the bottom to attach it to the shaft of the chariot or cart. Found near Maidstone (KENT-C01CA0).

17. Decorated copper-alloy and wood bucket (LON-E78C8A)
Late Iron Age (*c*. 75–25 BC)
Found near Lenham in 2019

This heavily damaged group of bronze sheet metal plates and cast fittings are all that remains of a large wooden bucket, covered in decorative panels with the large, cast, figurative handle fittings. The plates are decorated with repoussé decoration consisting of two large sea horses (hippocamps) tearing a small four-legged animal apart between them. Each seahorse has a bird behind. These decorated panels would have been paired in single bands around the bucket. In total, fragments of three bands were recovered, although only two remain to any large extent and no evidence of feet were recovered.

These fragments represent a bucket connected to the 'Aylesford-Swarling' culture, a particularly Kentish expression of late Le Tène art, ceramic production and burial practice heavily influenced by continental connections. The buckets could be quite large: the Aylesford bucket, now in the British Museum, is over 30 cm high. The known examples all seem to have been placed in cremation burials, sometimes even used as the primary container for the human remains. The fact that these fragments were recovered along with a heavily plough-damaged, small bronze bowl and ceramic fragments seem to imply this example was similarly deposited. Interestingly, the Lenham bucket seems to have had an extensive life before its deposition, the handle mount with a rectangular plate clearly being a replacement, as the original three rivet holes can be seen in the surviving plate. Thus it was unlikely to have been made specifically as a cremation container.

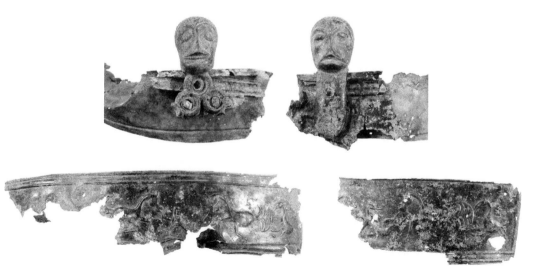

The most complete fragments of the Lenham bucket, showing the large figurative mounts for the heads and the hippocamps with large fan-like tails. These are the only representation of such classically Mediterranean creatures known in the La Tène art style outside of coinage in Europe.

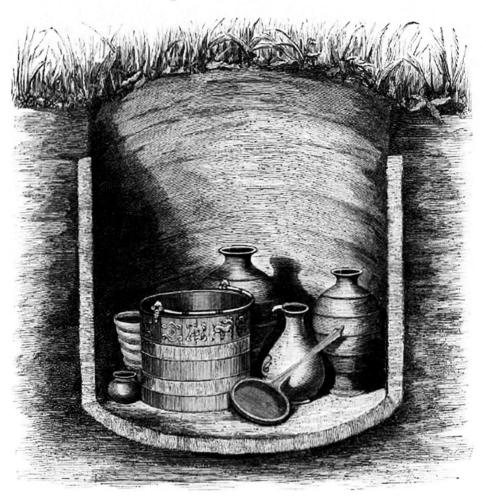

The reconstruction of the Aylesford bucket cremation burial, showing the many additional vessels placed in the wood lined grave. (CC-0 1890 Athur-Evans in Archaeologia 52: Late-Celtic Urn-Field at Aylesford, Kent, and on the Gaulish, Illyro-Italic, and Classical Connexions of the Forms of Pottery and Bronze-work there discovered)

Continuing the burial theme, this bronze helmet was found having been reused as a cremation container. A brooch and copper-alloy spike were found alongside it. It was produced from a sheet of copper alloy, hammered into shape with a slight neck guard. It has two parallel lines of incised cabled decoration running around the circumference: one follows the edge including the neck guard while the other runs above it, following the line of the bowl.

This grave assemblage roughly fits the pattern of cremation we saw previously in the Aylesford-Swarling bucket. However, the use of the helmet as a container is very unusual. The type isn't well paralleled in Britain, where the known helmets tend to be unique. Closer parallels are found on the Continent among Gallic helmets of the middle first century BC, though perhaps produced under Roman Republican influence. The brooch accompanying it is paralleled in contemporary insular burials in southern Britain. The cremated remains, where identifiable, appear to be female. While a martial identity may typically have been male in Iron Age Britain, it was not exclusively so, with occasional burials from places like East Yorkshire associating weapons with female graves.

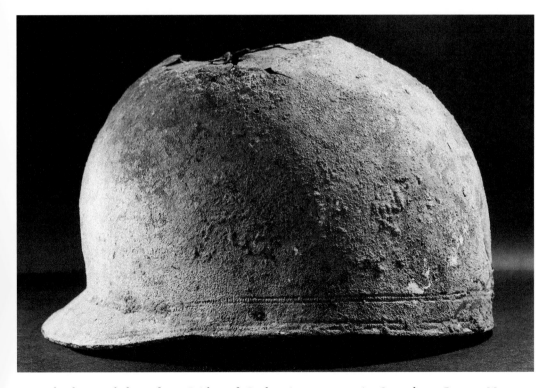

The bronze helmet from Bridge of Coolus A type, now in Canterbury Roman Museum. (© Canterbury Museums)

19. Bronze unit of Eppillus (KENT-12A3BD)
Late Iron Age (AD 1–15)
Found near Borden in 2017

With the growing influence of Rome during the first century BC and beginning of the first century AD, we see increasing imports, and Roman artistic elements enter the indigenous repertoire. This is very noticeable on the ever-expanding variety of coinage from Kent, now being struck in gold, silver and copper alloy. Many coins, like this struck bronze unit in the name of Eppillus, combine older elements like the butting bull with the imperial eagle of Rome. Inscriptions using the Latin alphabet, naming rulers or places, also become common, similar to naming conventions on Republican coins.

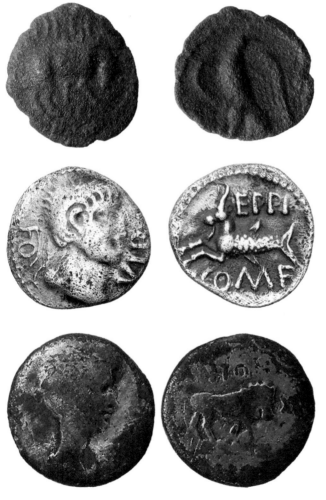

A struck bronze unit of Eppillus, depicting a butting bull with inscription '[EPPIL] / COF' and a Roman-style eagle on the reverse.

A silver Capricorn unit in the name Verica and Eppillus, which shows a Roman style bust on the obverse and a hippocamp on the reverse dating to *c.* AD 10–40. Found near Barham (KENT-DC656A).

A Roman silver republican quinarius of Mark Antony. Silver Roman coins like this, and the more common denarii, heavily influenced the indigenous coinage of Britain. Here we can see the artistic cues echoed in the previous two coins in the style of the head, and the animal on the reverse. Found in Egerton parish, October 2019 (PUBLIC-2EA3F1).

Chapter 5
The Romans in Kent

In AD 43 the Roman conquest began in Kent, with forces landing at Richborough before marching north and west to annex much of the rest of Britain. The people of the Cantiacii tribe and their land were reorganised under Roman rule to become the civitas Cantiacorum. There is no rapid change to people's everyday lives, the late Iron Age Cantiacii already heavily

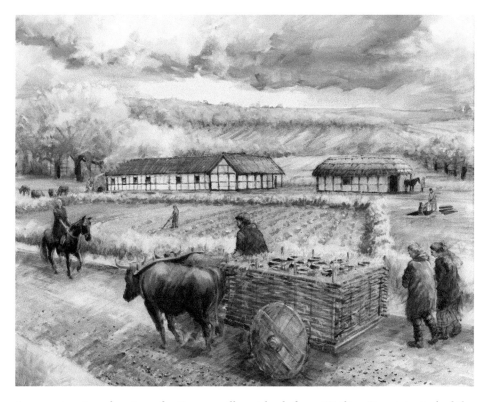

A reconstruction drawing of a Roman villa set back from Watling Street, typical of the villa estates in Kent. (© Alan Marshall)

influenced by Rome. The prolific use of Roman coinage is the most immediate cultural change. Around the end of the first century AD we see an expansion of Roman building with the construction of villas, a great triumphal arch at Richborough and an expansion and reordering of Canterbury on a standard Roman layout. The new settlements Richborough and an expansion and reordering of Canterbury on standard Roman layout. The new settlements provided for afterlife with cemeteries outside their wall. Some were very large with 500 bodies and a vast array of grave goods at Pepperhill. Temples and religious centres develop such as around Springhead's eponymous spring. Alongside this development the range and availability of goods people had access to increases, the majority of Roman brooches identified coming from this period. Imported goods also become more widespread including glass and ceramics.

The newly developed Roman road network, often utilising existing routeways, became a focus of settlement overtime. Small villas set back from the road and roadside settlements like those at Monkton, Thanet and Whitehawk Farm, Ashford, become relatively common. Thanks to how plentiful Roman finds are it is possible to track many of the Roman

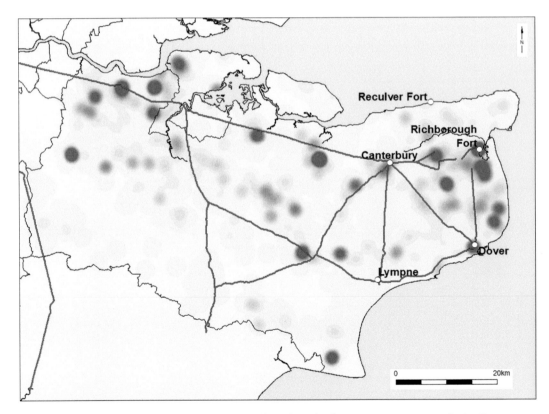

A heat density of Roman finds from Kent plotted with the major Roman roads in Kent. A number of other routeways and roads are known, although their exact routes are not yet clear. A third major road is thought to run east to west and may account for the large spike of Roman finds across the middle of the county. A similar explanation may account for the north-west and west of the county.

routeways and the associated settlements through stray finds. We also see expansion of settlement and industry in west and north-west Kent, with villas along the Medway and Darent river valleys, increased ceramics production in the Medway estuary and iron exploitation in the previously poorly exploited Weald.

Kent retained a Roman military presence after the conquest unlike much of the south-east, being an important connection to the Continent and a major base of the Roman navy. It may have been this connection and the watermills and agricultural support for the military that helped Kent weather the economic and civil turmoil of the later third and fourth centuries. This saw the Roman military presence strengthened with expanded fortifications at Richborough and Dover and whole new forts at Lympne and Reculver. Evidence of the Roman military is, however, sporadic outside of these centres.

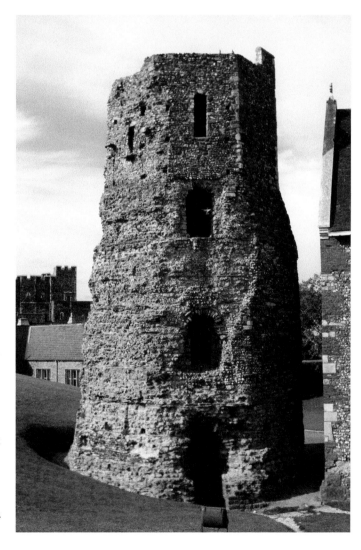

The Dover Pharos, the surviving example of a pair of Roman lighthouses likely built by the Roman navy in the late first or early second century AD to guide ships into port. It currently stands in the grounds of Dover Castle at a height of 19 m, though it and its twin on the Western Heights side of Dover are thought to have been 24 m high when new. (© Kent County Council)

20. Copper-alloy brooch (KENT-FAE63B)
Late Iron Age to early Roman (*c.* 15 BC–AD 63)
Found in Badlesmere parish in 2018
33.27 mm long

Other than coins, brooches, particularly of the first and second century, are the most common metal stray find from the Roman period. As with most brooches of the first and second centuries, this nearly complete though bent Colchester type bow brooch shows a continuation of fibula types we see during the Late Iron Age, though it has a coiled spring attached to its head via an axel fixing rather than a modified continuation of the bow as in earlier examples.

Further developments from the late first century include decorative enamel, headplates and feet. New types are also adopted from the wider Roman Empire such as circular or skeuomorphic plate disc brooches, the latter type mimicking the shape of everyday objects and body parts. Enamel is a particularly striking new technique and while used during the Iron Age access to the Roman glass and colourant supply allowed for more vibrant varied colours.

A simple early bow brooch of Colchester type. This type and its derivatives are the most common brooches we record with the PAS.

A sprung knee type bow brooch, a more developed fibula type dating to the late second/early third century with a cobalt blue enamel panel. Found near Wingham in 2019 (KENT-856711).

A second century Roman disc brooch with intricate enamel fields. Note the simplified hinge and catchplate arrangement without a spring. Found near Lenham in 2016 (KENT-331C53).

21. Bronze bowl (KENT-33C787)
Imported early Roman (*c.* AD 1–100)
Found in north-east Kent in 2016
333 mm in diameter

Imported early Roman objects are not uncommon in first century AD Kent but there is one particularly striking group of objects that stand out. Large beaten bronze bowls with elaborate handles often found with iron bars likely for suspension. These bowls represent imports from the Italian peninsula in a very Roman style. Though this example was found with two bars, it doesn't appear to have been related to a burial as many others were. Utilised as a cremation containers or grave goods, they, like the Iron Age helmet burial, could be seen as a continuation of Iron Age cremation practice. That being said quintessentially Roman style cremations, such as those found during the A2 widening work near Gravesend, also produce first century imported bronze vessels and serving dishes. Perhaps these objects are better seen as evidence for Kent's already close connection to the wider Roman world and the great wealth this yielded.

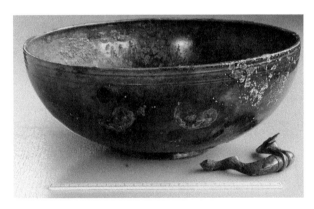

The bronze bowl with one of its two handles, both of which were attached when it was deposited, although the solder has come away while it was in the ground. (© Canterbury Archaeological Trust)

Iron Bar 1

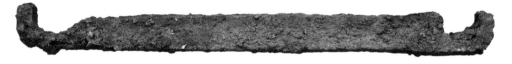

Iron Bar 2

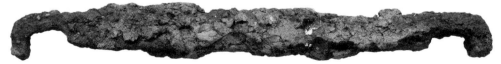

The hooked iron bars found with the bowl. Possibly intended to suspend it, although from what is uncertain. (© Canterbury Archaeological Trust)

22. Copper-alloy and iron hinge and plate (KENT-41A8CB)
Early Roman (*c.* AD 43–200)
Found in the parish of Otterden in 2018
21.09 mm long

Objects clearly associated with the Roman military are rare in Kent outside of the Roman forts and urban centres, particularly for the early period. This find was therefore a particular surprise as there is a dearth of Roman evidence in the immediate area. It is one half of the shoulder hinge from a set of roman lorica segmentate, the iconic armour of the early Roman army. It is formed of two copper plates riveted together through an iron plate of armour. It would have been paired with another set to link the shoulder plates together. To date this is the only example on the PAS database to have been found with both copper-alloy hinge plates and the iron plate of the armour.

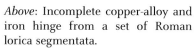

Above: Incomplete copper-alloy and iron hinge from a set of Roman lorica segmentata.

Right: A reconstruction drawing showing how the hinges would have functioned and their placement on the shoulders of the most common form of lorica segmentate. (© Edwin Wood)

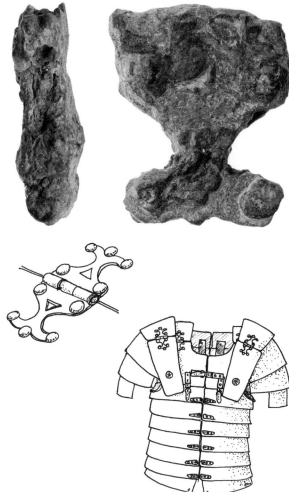

23. Rotary quern stone (KENT-C296C3)
Early Roman (*c.* AD 43–200)
Found on the coast of Sheppey in 2019
380 mm in diameter

Kent had a vital role to play in supplying the Roman military, with a number of watermills for the processing of grain found close to Richborough. Though slightly more modest than a full millstone, this upper stone from a hand operated rotary quern is still substantial and certainly at the upper end of the scale of what is recorded as stray finds. It roughly bun shaped with gently sloping sides, a concave top forming a conical hopper and a hole in the side for the now missing handle. The underside and handle have been worn smooth from extensive use and there is iron staining around both holds suggesting the handle and spindle had significant iron components. It was probably for the domestic production of flour rather than the government-run production at Ichkham. This quern is of a type known from other parts of the country in the late Iron Age but doesn't arrive in Kent until the early Roman period. It is made Folkestone Beds Lower Greensand stone suggesting that it was probably produced in or around Kent rather than being an early import.

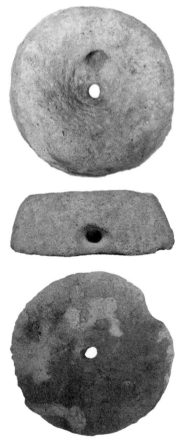

The upper stone of a rotary quern made from Folkestone Beds Lower Greensand stone.

24. Samian ware bowl (KENT-675FDD)
Early Roman (*c.* AD 160–230)
Found in Pegwell Bay in 2018
115 mm in diameter

While many of the objects in this book are metal or stone, by far the most common finds from pre-industrial archaeological sites are ceramic, whether pot, bricks or tile. Roman sites can produce a dizzying array of fragments from pots, plates, amphora and everything in between. It is very unusual for such items to survive complete outside of graves. This little Roman bowl was therefore a surprise.

Spotted nestling in sand by a canoeist in Pegwell Bay, it is a great example of a type of Roman pottery called Samian ware (Terra Sigillata). Its fine colour and smooth, slightly shiny surface made it very popular at the time and remains very recognisable today. It was widely used in the west of the Roman Empire by both the military and civil populations. Its production was initially at Arezzo in Italy and then moved to various locations in southern, central and eastern Gaul. Intricate moulded decoration is relatively common as is the application of a stamp to the base bearing the potter's name. Studying these features and the fabric of the vessels can significantly narrow dating.

Right: Small samian bowl, with a tiny central floral stamp.

Below: Two fragments of the same mould decorated samian bowl. The fabric (type of clay and its inclusions), the decoration and shape of this bowl help us to narrow its manufacture to *c.* AD 50–120 at the Lezoux kilns in central Gaul. Found in the Medway Estuary (KENT-3658A4).

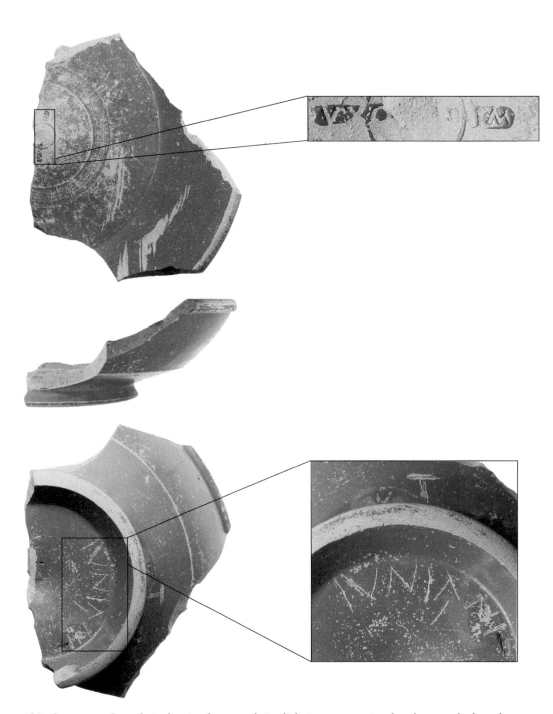

This fragment of a relatively simple central Gaulish Lezoux samian bowl not only has the maker's name stamped on the inside, 'VXOPILLI M' (Uxopillus), it has the owner's name scratched onto the bottom, 'IVNIANI' (Junianus). Dating to *c*. AD 150–180, it was found on the Thames Foreshore in north Kent (PUBLIC-FBA44F).

25. A gold magic amulet or earing (KENT-C296C3)
Second century Roman (*c.* AD 100–200)
Found near Faversham in 2018
18.3 mm in diameter

This enigmatic gold object is formed from two gold discs pressed and crimped together. There is a slight tear at the top where a probable suspension loop was situated. The decoration is the same on both sides depicting a heavily lidded almond-shaped eye surrounded by around nine animals or objects in the process of attacking it. The design is quite abstract, with an elephant, a scorpion and a winged phallus being the clearest. This is a classical trope known as the 'All-suffering Eye', where the evil eye is shown being warded off by the surrounding elements. To the Romans the scorpions and phalluses are powerful magical symbols thought to have *apotropaic* qualities, the power to ward off evil influence or bad luck.

This pendant is part of a small group of around twenty such gold amulets/earrings with this motif spread across the west of the Roman Empire. One other example known from Britain has been found in Norfolk (NMS-B9A004). This trope can also be found in other mediums such as a mosaic at the 'House of the Evil Eye' villa in Antioch, Syria, or on a marble relief at Woburn Abbey, Bedfordshire.

A gold apotropaic or magic amulet
from Faversham.

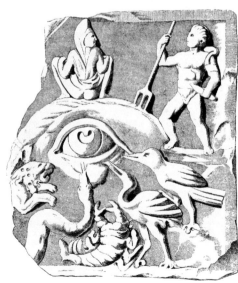

Figure 16: An illustration of the Woburn
Abbey relief showing the evil eye under
attack from magical elements such as the
trident, a snake and a scorpion and other
fearsome elements such as a lion, as well as
a Phrygian cap wearing figure appearing to
defecate on the eye to scorn it. (CO-0 1895
Elworthy, originally published in The
Evil Eye: an account of this ancient and
widespread superstition).

26. A copper-alloy sestertius coin (KENT-C4DF98)
Third century Roman (*c*. AD 225–227)
Found near Stockbury in 2019
30.32 mm in diameter

Roman coinage is by far the most common metal find recorded not only from the Roman period but also from all pre seventeenth century periods. The Roman coinage in Britain is roughly split into four groups: republican coinage to 31 BC, early imperial coinage from 31 BC to AD 260, the radiate coinage of 260–296 and the nummi coinage of 296–410. This example comes from the early imperial coinage, a Sestertius in the name of Sallustia Orbiana (AD 225–227), first wife of emperor Severus Alexander. The reverse shows Concordia, the goddess of harmony.

The sestertius was the largest of the copper-alloy coins officially issued to the provenance of Britain during the early imperial period and initially valued at one hundredth of a gold aureus, the primary gold coin of the time. The other commonly used copper-alloy coins were the dupondius and the as valued at half and a quarter sestertii respectively. The silver denarius also continued in use from the republican period and became relatively widespread. Although the majority of coins of this period were minted at Rome, other mints did operate, particularly in the east, of which some produced nonstandard coinage.

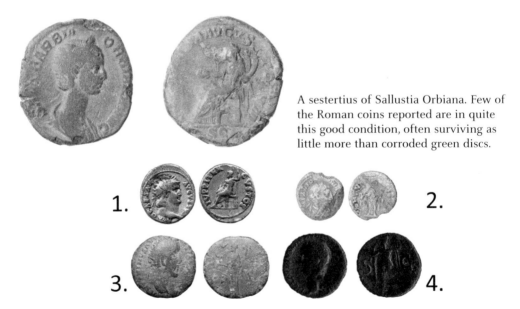

A sestertius of Sallustia Orbiana. Few of the Roman coins reported are in quite this good condition, often surviving as little more than corroded green discs.

1: Aureus of Nero from near Canterbury (FAIL-C77B04). 2: A silver denarius of Severus Alexander minted at Antioch. Eastern mints operated throughout the period though remain rare in Britain. Found near Wingham (KENT-8443D5). 3: A contemporary copy of a dupondius of Antoninus Pius (AD 138–161). Copies of coins aren't unusual but become very common in later coinages. Found near Shoreham (KENT-70B9A7). 4: A copper-alloy of Claudius minted at Lugdunum (Lyon). Mints other than Rome's in the west are only operated sporadically until the mid-third century. Found near Springhead (KENT-864795).

27. An emerald bead (KENT-E3AD5C)
Second or third century Roman (*c.* AD 150–275)
Found in the parish of Ash in 2017
9.2 mm long

Gemstones are not common stray finds from any period in Kent. Those encountered are usually associated with precious metal jewellery. In the Roman period these tend to be gold or silver rings and are used interchangeably with stones now considered 'semi-precious'. This tiny polyhedral bead is thus highly unusual. It is an emerald or another form of the beryl family of stones and has been drilled longitudinally. The shape is the natural hexagonal facets of the emerald that form in polyhedral columns.

The use of emerald/beryl beads is not well attested in Britain from later periods. When they do begin to occur in the post-medieval period, they tend to be used as polished cabachons or highly cut and manually facetted. We see these kinds of beads instead on gold Roman jewellery, particularly necklaces and bracelets occurring in the second to third century AD. These pieces were produced from gems imported from what is now India and Sri Lanka but likely made in the Mediterranean.

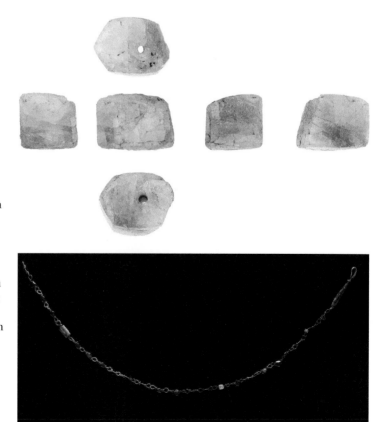

A polyhedral emerald bead with the clear hexagonal cross-section common among beryl stones.

A gold garnet and emerald necklace with a very similar emerald on the left side, found in a grave of a young woman at Gillingham and now in Maidstone Museum. Reported as treasure by Pre-Construct Archaeology.
(© 2020 Pre-Construct Archaeology)

57

28. A hoard of silver and gold coins (KENT-E5B4BB)
Late Roman (*c.* AD 395–402)
Found in the parish of Alkham in 2017. Fifteen silver coins, one gold coin and
 one ingot

Attempts to stabilise the Roman monetary economy with the adoption of the radiate coinage in the third century met with little success. So in 294 Emperor Diocletian reorganised and reformed the coinage. He created silver washed copper-alloy nummi and silver siliquae, with a replacement for the gold aureus in the form of the solidus shortly after.

The nummi soon spread across the Empire, produced at a number of provincial mints including, for a short time, London. By the middle of the fourth century some of the mints were probably producing nearly a million coins a day. The silver siliqua and the gold solidi remain fairly rare, though visibly increasing over the course of the fourth century. At the end of the fourth century/beginning of the fifth the particularly British practice of clipping the silver siliqua occurs. This likely takes place as an attempt to extend the faltering monetary economy with either bullion or new coins made from the clipped silver. It is particular noticeable in this hoard with almost all the silver coins being visibly clipped while the gold solidus is pristine.

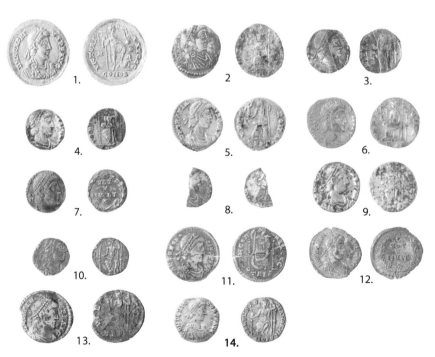

A hoard of fifteen silver siliqua spanning the reigns of Valentinian I (364–375) and Arcadius (383–395) and a gold solidus of Honorius (393–423). This roughly covers the period 364–402. Almost all depict the personification of Roma either seated or standing on the reverse, save for coins 7 and 12, which have commemorative wreaths to the ruler on the obverse, and the gold solidus (coin 1), which depicts the emperor.

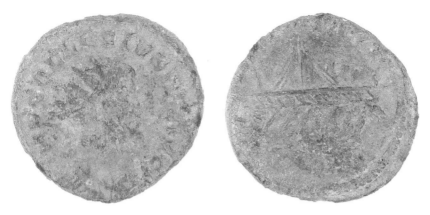

A late q-radiate minted at London by the British usurper Allectus (293–296). who ruled a breakaway Romano-British empire in the mid-290s. Minted at London *c.* 293–296. Found in Elham parish (KENT-572A57).

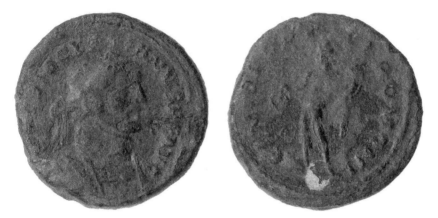

An early nummus of Diocletian (AD 284–305) minted at London, with the personification of Genius on the reverse. Found near Kingsdown (KENT-8A154A).

A very late nummus of Theodosius I (AD 379–395), depiciting victory on the reverse holding a trophy and dragging captive. This late coin, like its contemporaries, is substantial smaller than the early fourth century nummi. From near Canterbury (KENT-4FBF2C).

Chapter 6
Anglo-Saxon Kent

In AD 411 Emperor Honorius told the people of Britain to 'look to your own defence', officially severing Rome's authority. In desperation the Britons resorted to paying Germanic mercenaries to defend them. Myth names them as the Jutish warriors Hengist and Horsa and claims that they would eventually usurp the Britons' control of East Kent, with Hengist said to be the first king of Kent.

Whatever the exact truth, over the course of the fifth century the trappings of Roman rule fell away, and the archaeological evidence becomes more distinctly 'Germanic' in character. The monetary economy ceases, as does the widespread import and production

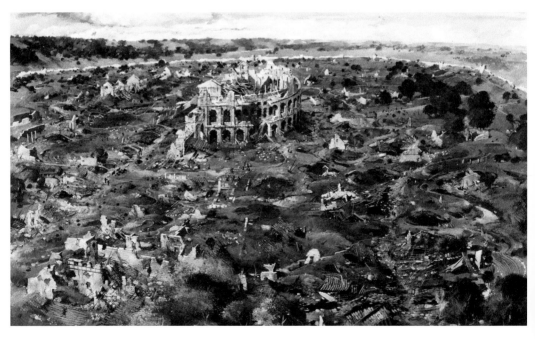

Reconstruction of Canterbury in the mid to late fifth century with small grubuts among the ruined Roman buildings. (© Canterbury Museums & Galleries)

of wheel-thrown ceramics. Most villas, forts and towns are abandoned or fall into ruin and are replaced by small farmsteads and villages made up of wooden long halls and smaller buildings with distinctive sunken floors known as grubhuts or '*Grubenhäuser*'. Like in previous periods settlement clusters around the coast in the east and north-east Kent and spreading west over time.

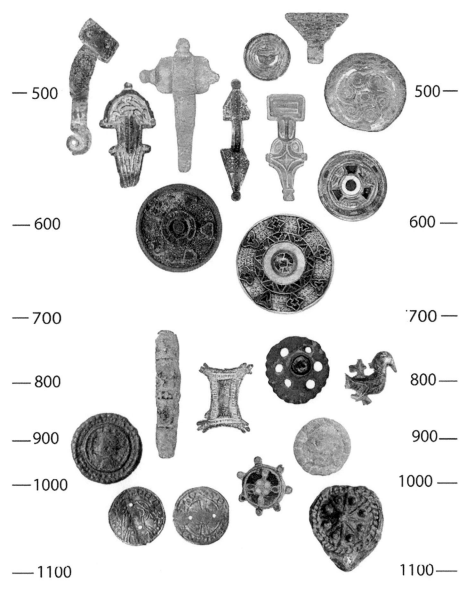

The great range of brooches in the Anglo-Saxon period and their change over time. Note the limited variety during the height of the kingdom of Kent in the late sixth to early seventh centuries.

These new settlements are not easily identifiable. Instead our evidence comes predominantly from the famous cemeteries dotting the county such as Sarre, Finglesham and Saltwood. Many utilised prehistoric barrows to stamp their ownership on the area. The vast array of objects in burials represents almost all the Germanic groups who settled Britain: Angles, Saxons, Jutes, Franks and others. Brooches are perhaps the most significant and obvious expression of these groups. Over the course of the sixth century these influences would coalesce into a distinctly Kentish style, which becomes very influential. Material found at Sutton Hoo and among the Staffordshire Hoard shows Kentish design cues.

By the end of the sixth century we see Kent at the apex of its power, solidified by the arrival of Augustine's mission to convert the Anglo-Saxons to Christianity in 597. From the middle of the seventh century Kent's power wained, falling first under the influence of Mercia, then Wessex, before being absorbed entirely into a nascent kingdom of England. While Kent never fully regains its power, Canterbury's influence continued to grow as the seat of Christianity in England. Dover and Rochester also grew in prominence. We see the establishment of monastic settlements and estates such as Lyminge where a stone church was built, and great secular estates whose influence on the organisation of the Kentish landscape remains to this day. The material evidence for this middle Saxon period is often scarce, lacking grave goods and brooches, which were common in earlier periods. However, we see the return of coinage, first with imported gold coins and then indigenously produced silver coinage, with coins becoming the dominant stray find of this period.

During the late Saxon period, towns and monastic centres continued to grow along with the economic wealth of the county. This is most clearly seen in the expansion of coin minting, defended settlements, and big building projects at Canterbury Cathedral and the Priory of St. Andrew (now Rochester Cathedral). The tenth-century Graveney boat gives us a snapshot of trade, containing Kentish ragstone mixed with continental lava quern stones and imported ceramics.

This growing prosperity unfortunately drew the attention of the Vikings, and the county suffered numerous raids that culminated in the sacking of Canterbury Cathedral in 1011. During this period, we see a resurgence of brooches, new clothes fittings and the expansion of coinage. Of particularly note is the explosion in horse furniture during the tumultuous period of the eleventh century.

29. Copper-alloy bracelet fragment (KENT-06B559)
Late Roman to early Anglo-Saxon (*c.* AD 425–475)
Found near Borden in 2016
43.7 mm long

While Roman control officially ended in 410, the Romano-Britons didn't disappear or absorb into Anglo-Saxon society overnight. Every so often we get a tantalising glimpse of their survival, most notably in the use of the Quoit Brooch Style (QBS) metalwork in which this copper-alloy bracelet fragment is decorated. The bracelet's decoration consists of a central four-trilobate foliate design in a square, originally flanked on either side by fields of decoration, culminating with a triangle of punched lines facing the middle of the bracelet with punched s-scrolls at the top. This is all framed by a running bar border. One half of the bracelet has snapped away, so the full design is not certain. These decorative elements are good indicators of QBS, although the most striking element – running or opposed animal motifs common on the brooches that give the style its name – are not present.

Most examples of QBS metalwork are recovered from Anglo-Saxon grave contexts and are very rare as site or stray finds. This example was found on what is now thought to be a Roman villa, with most stray finds indicating occupation up to at least the end of the fourth century. This is particularly interesting as QBS, while mostly seen as a mid to late fifth century art style on women's accessories, has its origins in late Roman military gear found around the Rhine Delta and English Channel. Indeed, the best comparisons for this bracelet are spread from cemeteries at Mucking, Essex, to Saint-Marcel, Brittany.

A quoit brooch style bracelet with distinctive geometric motifs.

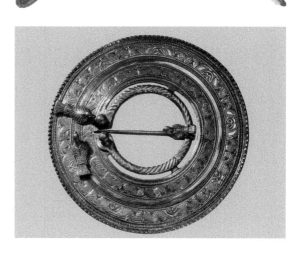

A silver quoit brooch from the Cemetery at Sarre, one of the type objects from which the style was identified. (© The Trustees of the British Museum)

63

30. Gold, garnet and glass mount (KENT-7FA24B)
Late fifth to early sixth century Merovingian Frankish (*c*. AD 450–525)
Found near Chislet in 2017, now in Canterbury Museum
15.89 mm in length

This small mount is made of composite sheet gold, soldered together with three semi-circular garnets arranged around a dark green triangular glass, all set within separate cells. It would likely have been attached to a buckle plate or possibly a finger ring. The technique used to create the cell work and the shape of the garnets is typical of cloisonné work produced in the late fifth and sixth century by the Merovingian Franks.

The Franks were a Germanic group who controlled of much of what is now modern France, Belgium, the Netherlands, western Germany and northern Italy. Frankish finds are not common but do appear sporadically in Kent, with gold coins probably attributable to the Franks appearing in the sixth and seventh century. Frankish objects are more common as grave finds at the end of the fifth and beginning of the sixth century. These Frankish finds are even rarer outside of Kent and this has in the past been used to support the idea that Kent fell under the control of the Frankish king. However it now appears more likely that members of groups who had settled Kent went on to settle areas along France's channel coast and further afield to south-west France.

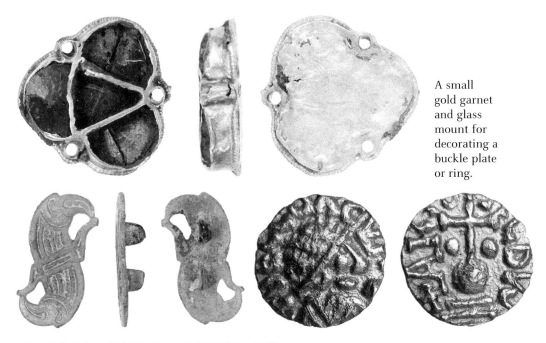

A small gold garnet and glass mount for decorating a buckle plate or ring.

Above left: A Frankish bird brooch (KENT-D90FBC).

Above right: A Frankish tremissis gold coin, minted at Beauvais, France. Found near Canterbury (KENT-7A24B0).

31. Anglo-Saxon grave assemblage (KENT-0AF0AE)
Early Anglo-Saxon, second half of the sixth century (*c.* AD 450–525)
Found near Elham in 2016

Found spread over a small area in the topsoil, this assemblage is made up of a gilt-silver disc brooch with garnet and niello (a black silver/sulphur mixture) inlay, a silver belt set and a copper-alloy buckle. This group of objects almost certainly represents the remains of a woman's burial with similar buckles found in graves across much of Anglo-Saxon England and northern Europe in the sixth and early seventh century. The brooch is, however, a very specific type known as a keystone disc brooch, which is seldom found outside of Kent and the Isle of Wight (which had similar settlement to Kent).

The use of garnet in brooches such as these and their small, squared-headed predecessors in Kent may be thanks to the influence of Frankish garnet work, as seen in the previous object. The garnets themselves are likely to have been from Sri Lanka and the niello's sulphur from Sicily. So, despite these objects being seen as a display of a Kentish insular identity, they are intrinsically linked to the wider world.

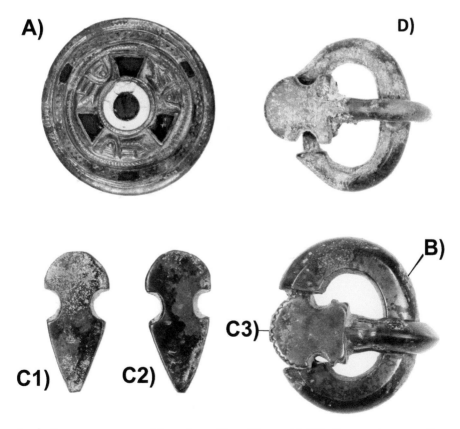

Anglo-Saxon grave assemblage from Near Elham, A) Gilt-silver and garnet disc brooch. B) Silver buckle. C) Rest of the silver belt set made up of two mounts and the buckle's tongue.

32. Anglo-Saxon silver sceat (KENT-DB3CoC)
Middle Anglo-Saxon (*c*.725–745)
Found near Swanley in 2016 and selected by West Kent Metal Detecting Club
13.29 mm in diameter

Over the course of the seventh century, coinage began to return to England, becoming relatively common by the beginning of the eighth century. Initially this was with gold coins, small *tremisses* and rarer solidi, mostly originating on the Continent and aping Roman style. These coins likely circulated as bullion rather than currency and were replaced by smaller, more practical silver coins known as sceatta or, singulary, a sceat.

The sceatta were a very varied but relatively short-lived group of coins, in use from 685–750. Geometric designs, stylised busts and zoomorphic designs (as seen on this example) are all popular designs on such coins. On one side we have a standing bird with a cross in front (often described as a sea bird or, due to the cross, a dove) and on the other, a four-legged quadruped (a wolf or beast). Such motifs are common in other art forms from the middle to late Anglo-Saxon periods. The sceatta were phased out and replaced by the earliest pennies. Though some of these early pennies utilised similar designs, by the end of the period they were becoming more standardised with inscriptions, a mint signature, depictions of ruler's busts on the obverse and Christian imagery on the reverse.

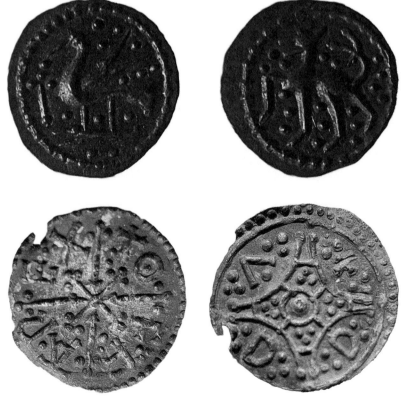

A silver sceat of type Q, likely Anglian in origin.

An early penny of Offa king of Mercia, dating to *c.* 765–792 and minted at Canterbury by the moneyer Vdd. 17 mm in diameter. Found in north-east Thanet (KENT-F85318).

33. Late Anglo-Saxon leather shoe (KENT-1122CD)
Middle Anglo-Saxon (*c.* 942–996)
Found near Gravesend in 2018
230 mm in length

Metals, stone and ceramics are often pre-eminent in the archaeological record, primarily since they survive well in most burial environments. But thanks to beach combers and mudlarks exploring rivers and coastlines, we sometimes get a snapshot of the organic materials likely to have dominated much of the material cultures of the past. One such example is this fantastic leather shoe recovered from the Thames bank in north Kent.

The shoe is of a simple 'foot bag' type, being a single piece of leather folded over the foot with integrated sole. The stitching may show it to be a turnshoe, a group defined by the stitching together of the shoe and sole, which was then turned inside-out. Turnshoes were used through the Middle Ages in Europe and similar types with stitching around the mouth have been recovered from late Anglo-Saxon/Anglo-Scandinavian deposits at York and early high medieval contexts from northern Europe. The dating for this example was established by a C-14 dating, which arrived at a date of 969 ± 27.

A hand-stiched leather turnshoe dating to the late Saxon period.

34. Late Anglo-Saxon nummular disc brooch (KENT4433)
Late Anglo-Saxon (*c.* 775–1100)
Found in Newchurch parish in 1997
29 mm in diameter

During the early Anglo-Saxon period it was not uncommon for imported gold coins to be modified and utilised as pendants or other pieces of jewellery. This fashion does not appear to have lasted much beyond the circulation of these coins. The use of coins as jewellery or

Not to scale. Top: KENT4433, a nummular brooch probably copying a coin of Carolingian Frankish king Lois the Pious. Middle left: KENT-5E6A92, an early Anglo-Saxon imitative gold solidus coin converted for use as a pendant, *c.* mid-seventh century. 18.25 mm in diameter. Middle right: KENT-1F30C0, a medieval silver brooch made from a Gros Tournois coin of Louis IX of France (1226–70), minted between 1266 and 1270. 25mm in diameter. Bottom left: KENT-E73D1B, a post-medieval silver cufflink utilising a milled colonial one half real of Philip V of Spain (second reign, 1724–46) dated 1742, minted at Mexico City. Bottom right: KENT-2703B3, an Early Modern cast copper-alloy enamelled medal or badge, imitating a crown of George III dated '1818'.

the influence of coins on jewellery does, however, resurface at the end of the eighteenth century. Initially we see the production of disc brooches imitating contemporary coinage from Britain and France as well as, in some rarer cases, Roman coinage.

These brooches are referred to as nummular brooches, of which this is a fine example. We see an imitative bust on one side with three circular borders, the outer two being beaded. It has an unusual catch and pin lug arrangement, wherein the pin is wrapped round a simple rectangular fixing almost unique to the mid–late Anglo-Saxon period. Of particular note is the beaded border that is found on various disc brooches of the time. These tend to get more ornate and extravagant over time, a famous example from Canterbury having no less than twelve borders!

By the beginning of the eleventh century these brooches begin to fall out of fashion, and we see them replaced with coins modified into brooches. This new fashion is, however, short-lived and does not last much beyond the end of the eleventh century. The use and influence of coins (and similar objects) as jewellery is widespread. In some cases, the precious metal coins make a useful resource for producing objects, but in others the symbolic significance has clearly influenced their utilisation.

35. An early Turkish copper-alloy polyhedral weight (PUBLIC-009751)
Late Anglo-Saxon to medieval (*c.* 900–1200)
Found near Sittingbourne in 2019
12.48 mm x 16.31 mm

Artefactual evidence for the Vikings presence in Kent is sporadic and mostly limited to a handful of brooches that may be of Viking influence, more commonly found north of the Danelaw line dividing England between Viking and an Anglo-Saxon control. This is despite the fact that from the ninth century to early eleventh century Kent was finding itself under regular Viking attacks, with a force attacking the Isle of Sheppey in 835 and then over-wintering on the island in 855. One object recently discovered near the Swale channel (which divides Sheppey and mainland Kent) may, however, point to their presence in the area.

This polyhedral copper-alloy weight was designed to be placed in a pan scale. It has incised ring and dot decoration on each of its twenty pentagonal facets, save for two large hexagonal facets on the top and bottom. One of these hexagonal facets is too worn to discern anything, although the other appears to have Arabic or pseudo-Arabic inscription on it. This inscription isn't entirely clear and appears to resemble the Arabic spelling of 'Iman', though if this is the case it is likely in reference to 'truth' rather than a religious leader.

It has long been known that the Viking had contacts with the Eastern Mediterranean and acquired the fashion for similar polyhedral weights. Viking polyhedral weights are of a slightly different form however, with their facets made up of squares and triangles. None have so far been reported south of the Danelaw. A number of very similar examples to this are, however, known from modern Turkey. Indeed, the closest examples found are held by the Museum of Ankara, some with short inscriptions.

Left: A copper-alloy early Turkish polyhedral weight dating to *c.* AD 900–1200. Right: A Viking polyhedral weight dating to *c.* 900–1000. 8.5 mm x 8.5 mm. From Sandringham, Norfolk (NMS-998885).

36. An Anglo-Scandinavian copper-alloy stirrup strap mount (KENT-044037)
Eleventh century
Found near Lympne in 2018
12.48 mm x 16.31 mm

During the eleventh century the long-term interactions between Viking, Scandinavians and Anglo-Saxons in England produces a distinctive art style referred to as Anglo-Scandinavian. Much of this art continues the favoured use of zoomorphic, human mask and vegetative elements seen earlier in the period. This new style is utilised heavily on horse furniture and fittings, which become common during this period, having previously been quite rare.

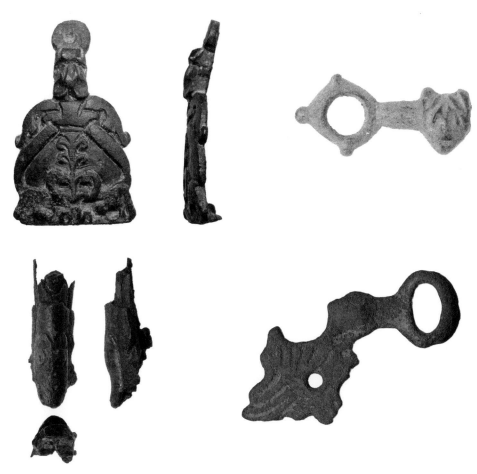

Above left: KENT-044037, a stirrup strap mount alongside other pieces of eleventh century Anglo-Scandinavian horse furniture. Above right: KENT-4D8F5B, an incomplete copper-alloy two-way harness link with central zoomorphic boss, 44.72 mm long. Bottom left: Decorative zoomorphic cooper-alloy stirrup side terminal, with part of the iron stirrup remaining. Bottom right: An incomplete copper-alloy bridle cheek piece.

One element of horse gear found relatively regularly is the stirrup strap mount, designed to hang the newly adopted iron stirrup on straps from the saddle. These were almost all made of copper alloy. This example has three sinuous beasts, two curled round the outside with the heads facing out and flanking the projecting apex, which has a more defined beast's head facing upwards with a blunt snout and wide round ears. It is in surprisingly good condition, with its detail fine and crisp and its fixing not worn or broken. This is unusual as most pieces of horse gear recovered are heavily worn and broken, likely due to extensive use and their often relatively fine construction. While regarded as quite uncommon, they are recovered fairly regularly in Kent, particularly the south-east of the county, and we can reconstruct a set of horse furniture from the county's finds.

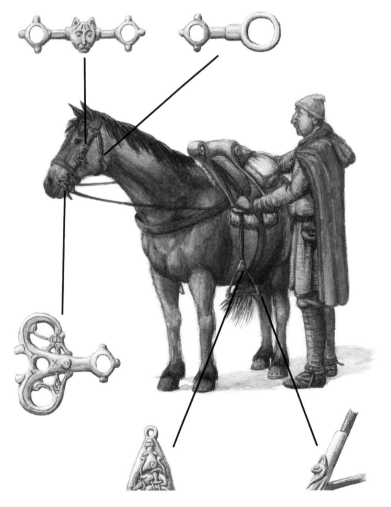

A reconstruction drawing showing how eleventh-century Anglo-Scandinavian bridle furniture would have been used. Reproduced with thanks. (© Dominic Andrews)

Chapter 7
Medieval Kent

Kent was on the frontline of the conquest of England by William the Conqueror in 1066, as he marched from Hastings to London via Canterbury and then along the coast to London. The old elite was swept away and mostly replaced by francophone Norman-French. Over the next century or so the new elite imposed new ideas upon the country, which merged with established Anglo-Saxon English cultural traditions and lead to the creation of medieval England. There is very little obvious change in material culture for the rest of the eleventh century with the Anglo-Scandinavian style metalwork surviving until the early twelfth century. Twelfth-century material, such as distinctive small buckles with backward facing zoomorphic terminals, are relatively rare. There appears to be a great deal of overlap with the proceeding and subsequent centuries. This is in contrast with the wider landscape and archaeological evidence: Norman influenced Romanesque architecture is introduced and the first castles constructed, including Dover, Rochester and Canterbury. Over the next few centuries the widespread need for such castles declines and more comfortable estates such as Ightham Mote and Scotney Castle are built.

The Norman keep at Rochester, typical of eleventh and twelfth century stone-built castles. (© Kent County Council)

The power of the church continues to expand from the late Saxon period throughout the medieval period until the Reformation. It was a major landowner, owning large tracts of land in Kent together with castles, manors, monastic estates and even towns. The importance of Canterbury increases even further after the martyrdom of Thomas Beckett at the cathedral in 1170. This roughly coincides with an increase in overtly religious objects including processional crosses, reliquaries, pilgrim badges and book fittings all likely related to the church or worship.

Although Dover, Canterbury and Rochester were centres of church and royal organisation, towns were mostly small though relatively numerous. They provided a forum for merchants and craftsman to work and provided a regular market for them and farmers from the surrounding area to trade. Most people lived and work in a rural setting with many of Kent's modern villages and hamlets having a medieval origin. Many of these rural communities would come together for religious events, markets and fairs where people would trade for goods. These would take place at towns and rural settings close to villages or at a convenient meeting point between dispersed settlements. Some can be identified by scatterings of lost silver coins and other detritus of business such as seal matrices.

Another important element of medieval Kent were the Cinque ports, a loose confederation of coastal towns mostly in Kent and East Sussex that were to provide ships to royal naval requirements in return for a waving of import duties at the member ports. These were originally Hastings, New Romney, Hythe, Dover and Sandwich but expanded over time as harbours or rivers silted up and subsidiary towns grew in importance such as Rye and Folkestone.

Seals of the Cinque ports of Kent. (CO-0 1892. William Boy. Collections for an History of Sandwich in Kent. With notices of the other Cinque Ports and members, and of Richborough)

37. A silver penny of William I (KENT-D697ED)
Medieval (*c.* AD 1074–77)
Found in Burmarsh in 2015
19.1 mm in diameter

Soon after the conquest of England William I 'the Conqueror' (1066–87) set about establishing his authority and his dynasty. One of the key elements of this was publicising his own power and image while also sweeping away the last vestiges of Anglo-Saxon rulers. He was keen to replace the Anglo-Saxon pennies in circulation with new coinage bearing his likeness. Existing mints such as Canterbury, Rochester, Hythe and Dover were quickly switched over to this new coinage, with a new mint opened at Romney. This penny is a rare example of a penny

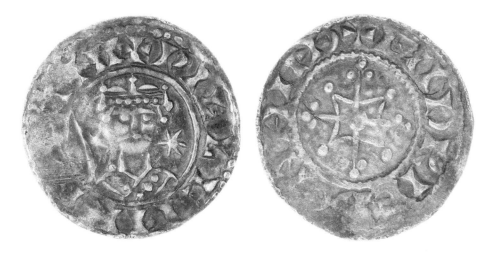

A penny of William I minted at Hythe by Eadred.

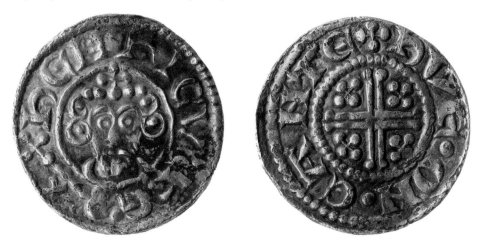

A short cross penny of King John (1199–1216). A type initially produced by Henry II. Minted at Canterbury by Hue. Found near Waltham (KENT-85FC53).

75

of William I, from the mint at Hythe issued by the moneyer Eadred. On the obverse it shows William I crowned with a diadem between two stars and on the reverse a decorative cross.

This coin isn't too dissimilar to later Anglo-Saxon designs. Pennies, however, remained relatively varied in design until Henry II's (1154–89) reign, who attempts to standardise the designs. Initially with the poor quality, short-lived Tealby type and then the longer-lived short cross pennies. The short cross pennies survive until the reign of Henry III (1216–72), though the only mint in Kent to survive this period was Canterbury. Henry III replaces these with voided long cross pennies to facilitate small change as they could be easily split into halfpennies and quarter pennies (farthings). His successor Edward I (1272–1307) introduced yet another group of pennies, the long cross type, but supplemented these with a range of halfpennies and farthings. This type remains in use until the beginning of the post-medieval period under Henry VII (1485–1509).

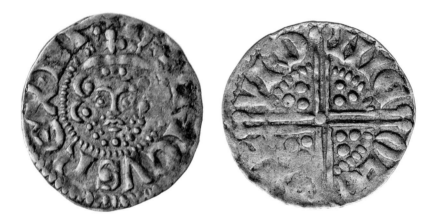

A voided long cross penny of Henry III (1216–72). Minted at London by Nicole. Found in Saltwood (KENT-0687CB).

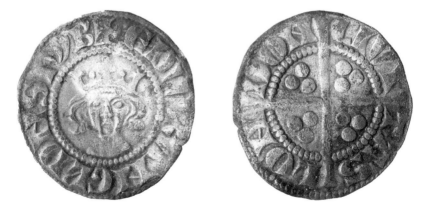

A long cross penny of Edward I (1272–1307), minted at London. A type in use until the reign of Henry VII with only minor changes. Found near Woodnesborough (KENT-BF4AA4).

38. An inscribed knife bolster or end cap (KENT-D7B5E0)
Late early-medieval to medieval (*c.* AD 1050–1150)
Found in Brenzitt parish in 2018
25.7 mm in length

This small knife fitting is an intriguing object, cast in copper alloy and roughly hexagonal in cross-section with two faces being quite narrow. An inscription has been laid out on four of the faces leaving one of the narrow faces and one of the wider faces without lettering and filled instead with decoration. It reads 'EA:/DPIN/EM[E.]/EEIT', a slightly misspelled Old English inscription likely 'EA:DꝥINE M[E] [F]ECIT', which translates as 'Eadwine made me'. This follows a well-known Anglo-Saxon epigraphic formula, in Latin or Old English. The lettering serifs, use of the Old English letter wynn (P/ꝥ) and the Old English personal name Eadwine roughly fit a late eleventh or early twelfth century date.

The misspelling appears to be due to poor placement and spacing of the words. Taking this into consideration with the fact it reads bottom to top and that the decorative panels have been placed in margins laid out for lettering, it is likely that the artisan, Eadwine, was copying a continuous written text not set out as it was to appear on the fitting.

Only a handful of similar fittings are known, most notably on the knives from Waterford in Ireland and Winchester, Hants., both recovered from archaeological contexts dating around the twelfth century. It is interesting that such an overtly Anglo-Saxon style of inscription survived well into the Norman period. The possible religious connection of such knives suggested by inscriptions on the Waterford example and a few of the other known fragments may have contributed to the continuation of this indigenous tradition.

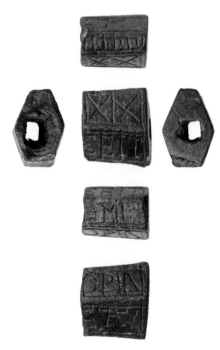

The Brenzett knife fitting, with ruse on a number of faces and the longitudinal hole like from the knife's iron tang.

39. A gilt copper-alloy and rock crystal relic mount (KENT-B32E3D)
Twelfth or thirteenth century (*c.* AD 1100–1250)
Found in Burmarsh in 2016
42.17 mm in length

The dominance of the church in Kent and the vital role religion played in medieval England is very clear in the material culture recovered. Fixtures and fittings with religious iconography are not uncommon. With examples from books, small shrines or chests have all been found in the county. Others such as this example are not overtly religious but thanks to surviving examples (some still owned by the Catholic Church) we can deduce it comes from a reliquary. This gilt copper-alloy mount has a large central cell with a large piece of polished rock crystal set in it. Such reliquary contained objects or even human remains of important religious significances known as relics. Many of these fine boxes can trace their origin to the French city of Limoges, renowned for producing inlaid enamel and rock crystal during the twelfth and early thirteenth centuries.

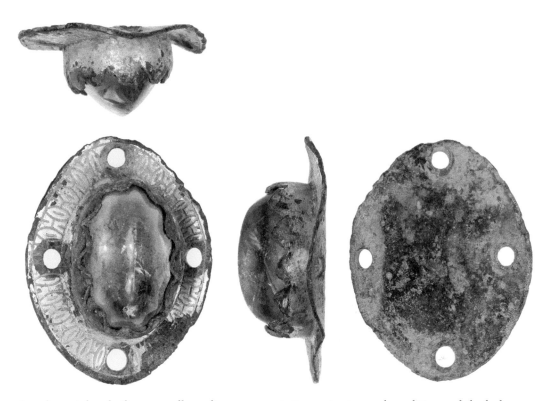

A rock crystal and gilt copper-alloy reliquary mount. It remains in good condition and the lack of damage around the fitting points may suggest it was carefully removed from its original reliquary.

A gilt copper-alloy mount from a processional cross used in religious ceremonies. Decoration is more overtly religious with its depiction of the haloed eagle of St John the Evangelist. Found in Swingfield (KENT-732442).

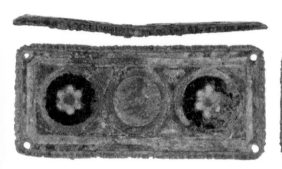

A mount decorated with Limoges style enamel inlay. Probably from a book, chest or reliquary. Although much of the Limoges output is religious, it isn't universally so may have been for a secular object. Found in the parish of Lyminge (KENT-DFBFBC).

40. A gilt copper-alloy and enamel figurative heraldic mount (KENT-FF3C2C)
Late thirteenth or early fourteenth century (*c.* AD 1230–1325)
Found in Egerton in 2018
39.18 mm in length

This gilt copper-alloy mount is decorated with an enamel heraldic device and a female figure placed over the top of the design. Armorial heraldry often displayed on shields or on a shield device was adopted during the twelfth century. They were used on seals to sign and certify documents as well as display familial achievement and social/national allegiance on objects. The association with a female figure is unusual with few women being directly associated with heraldry on metalwork.

Although some heraldic motifs are paired with female religious figures, this example seems to be secular, shown in a posture and garb typical of the thirteenth century with no obvious saintly symbolism such as a halo or saint specific accoutrement. It seems therefore probable that the figure represents a female member of the family whose heraldry are presented here. The design or arms consist of a red border diagonal bands of alternating gold and blue, heraldically described as 'Bendy of six or and azure a bordure gules '. These arms are associated with the French counts of Ponthieu and the Duchy of Burgundy from the twelfth century to *c.* 1361.

A number of powerful and important women were associated with these noble houses. These include the Duchess Agnes (1271–1306, regent of Burgundy 1306–11) and Joan the Lame, Queen of France (1328–49), could be candidates from the House of Burgundy while the countesses Marie (1221–50) and Joan II (1251–79) of Ponthieu might be candidates from Ponthieu. The cross-channel links with northern France and Joan II's close links with the English crown via her daughter Eleanor's marriage to Edward I of England make her the most likely candidate.

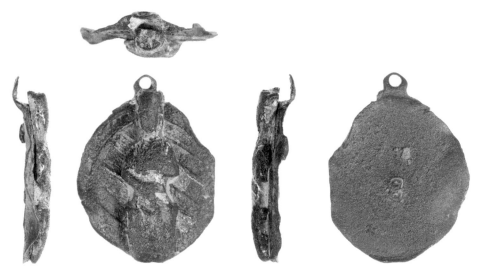

A heraldic and figurative pendant. Much of the enamel and gilding has worn away and the abraded edges likely removed similar fixing points to the apex one from the mount.

A depiction of Marie Countess of Ponthieu (1221–50) as seen on a seal impression. She is depicted wearing a similar barbette (headdress) with a crenelated fillet or a crown to that of the Egerton mount (CO-0 1880 Germain Demay, Le Costume au Moyen âge d'après les sceaux).

41. A lead papal bulla (KENT-686978)
Early fourteenth century, (c. AD 1305–1314)
Found near St Margaret's at Cliffe in 2018
39.4 mm in length

While the English church was powerful it remained under the control of the Catholic pope during the medieval period. The direct power of the papacy is not represented well in finds save for one group of directly linked objects, the papal bulla. These objects are lead seals attached with silk or cord through papal documents to guarantee their authenticity. After the document served its purpose some bullae were reused as devotional objects. The obverse shows the name of the reigning pope, in this case 'CLE/MENS/PP:V', for Clement V. The reverse shows the design standard from the eleventh century of the heads of St Peter and St Paul under their names. This particular example is very narrowly dated owing to the short tenue of Clement V.

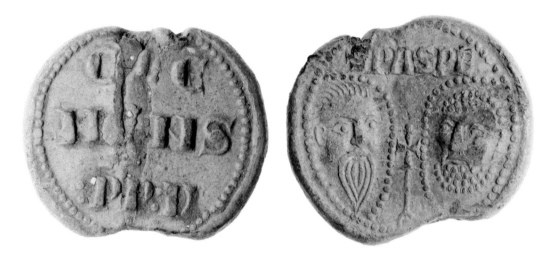

A lead papal bulla of Clements V. The slight indentation along the bottom of the obverse aligns with the longitudinal hole for suspension from the document.

42. A copper-alloy seal matrix (KENT-25C1E6)
Mid-fourteenth century (c. AD 1342–47)
Found in Kingswood Challock
39.4 mm in length

While the papacy was sealing their documents with lead seals, most people of the thirteenth and fourteenth centuries used wax. Matrices, the objects used to make wax impressions, are very common in Kent, perhaps due to its role in trade to the Continent and the heavy presence of the church. They have varying designs and inscriptions, usually running anti-clockwise around their circumference so the legend appears the correct way around when used. Many matrices name individuals some known from historical documents, specific institutions or even roles. This particular example names the Bishop of Lincoln with an abbreviation of '*SIGILLVM EPISCOPI LINCOLNIENSIS*'. Compared to the general matrices of the period it is very large, though this isn't unusual for those belonging to high status individuals and institutions. It is, however, not a bishop's personal seal, which would have been made in silver and destroyed after his death. For day-to-day use, however, his staff and retainers may have used a copper alloy like this example

Why a seal naming the Bishop of Lincoln has surfaced in Kent isn't entirely clear. However, it just so happens that a thirteenth-century clerk to Thomas Bek, Bishop of Lincoln (1342–47), Nicholas De Falle, was installed as parson of the nearby church at Boughton Aluph. Perhaps he continued to work for the bishop after his move to Kent or it was kept as a souvenir. There is also the possibility this matrix was a forgery intended to assist in fraud, perhaps relating to a debt owed by De Falle and the church at Boughton Aluph mentioned in documents from the late 1340s.

Above: The near complete seal of a Bishop of Lincoln, probably Thomas Bek.

Right: Impression of Bishop Bek's seal as taken by the finder.

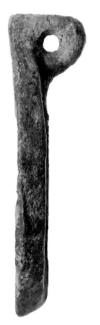
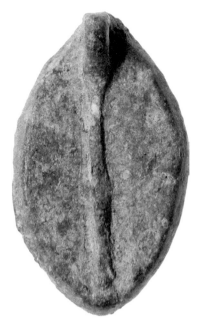

A more common simple lead seal of Isabel, daughter of William. Women's names aren't unusual on such matrices and usually found on pointed oval matrices (rather than circular). Found in Ivychurch parish (KENT-C10831).

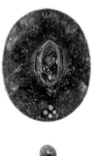

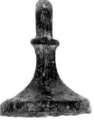

By the early fourteenth century most small seals ceased to name people, moving towards anonymous pious and popular mottos like this example's French romantic motto. Of note also is the orientation on the top of the matrix to show which way up it should be used. Found in the parish of Ivychurch (KENT-C617F2).

43. A hoard of gold nobles and a purse bar (KENT-D29B09)
Late medieval (*c.* AD 1452–1500)
Found near New Romney. Six coins and one purse bar

Although silver pennies predominated the monetary history of the medieval period, Edward III (1327–77) recognised the need to provide both lower and higher denominations. This included providing silver farthings and halfpennies and providing two larger silver denomination: the halfgroat (two pence) and the groat (four pence). A series of gold coins were also introduced with the noble and its fractions being most common. The noble was worth six shillings and eight pence (roughly eighty pence).

This hoard or purse loss consists of six nobles spanning the period of 1351 to 1361, valued at roughly two pounds. All are in good condition except one which is a plated contemporary forgery and has fragmented while in the ground. Unusually they were recovered with a purse bar, which is dated to the later fifteenth century, almost a hundred years later. Taking the value of the coins into consideration it is possible the coins were removed from circulation for a period, then during the latter half of the fifteenth century put in a purse and then lost or deposited.

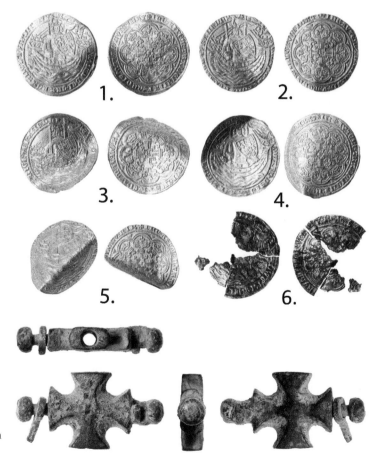

A group of five gold nobles (1–5) and one contemporary forgery of a noble (6). Most remain in good condition, although bent in some cases.

A late fifteenth century purse bar of Williams type E. The purse bag would hang from the loops at the end of the bar and the central perforation would hold a rotating loop to attach the purse to a belt.

85

44. A gold iconographic ring (KENT-D29B09).
Late medieval (*c.* AD 1400–1532).
Found near Eastchurch in 2019, selected by Medway History Finders MDC
33 mm high

In the late medieval period, a new fashion developed for a more personal mystic relationship with God, to be achieved through prayer and contemplation, and which could be aided by devotional objects such as pilgrims' badges, plaques and rings. Iconographic rings are the epitome of such practice and were frequently given as New Years and wedding gifts. They were a predominantly fifteenth-century phenomena, originating with the cult of saints some point in the late fourteenth century, with the type not surviving the English Reformation. This example has twisted band and iconographic designs on each shoulder, the Madonna and child on one and St Catherine with her wheel and sword on the other. The shoulders flank an unusual signet ring style bezel with enamel rays emanating from it. The signet bezel ring is of a type popular in the fifteenth or sixteenth century depicting a bull's head with an uncertain initial between the horns. This particularly example's bull's head is reminiscent of the canting arms of the Boleyn family and with its findspot near Shurland Hall, owned during the period by a cousin of the family it may well have belonged to Thomas Boleyn or other senior member of the family at the time.

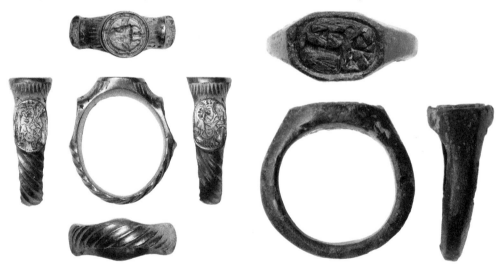

Above left: A hybrid iconographic signet ring with spiral band and bull's head signet. The enamel may have been a more vibrant colour initially but has degraded over time.

Above right: A medieval or early post-medieval signet ring with a crowned 'R' on the bezel. Selected for inclusion by the Cliffe Metal Detecting Club.

Chapter 8
Post-Medieval and Later Kent

The sixteenth century brought a great change to Kent and England as a whole with the solidifying of Tudor power and the reformation sweeping away of many of the established institutions such as Kent's numerous abbey and monasteries. Many were torn down, their property sold off and sites built on. It may be that a good number of the fragments of medieval religious objects found date from these events. Trade and industry shifted and

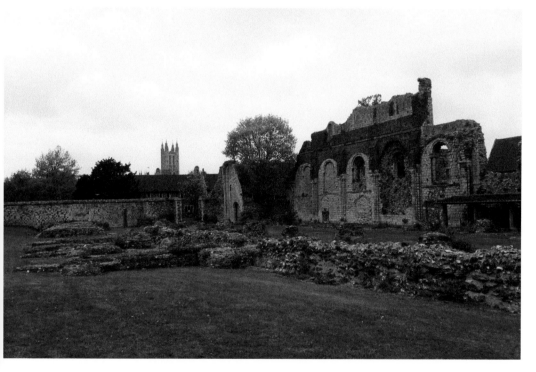

The remains of St Augustine's Abbey at Canterbury looking back towards Canterbury Cathedral. Even the abbey set up by the saint who returned Christianity to Britain could not escape Henry VIII's dissolution. (CC BY-SA 2.0 2011, Pauk)

expanded with the Cinque ports effectively becoming obsolete, save for Dover as trading centres, and military production moved to the Thames and Medway estuaries and Kent's northern coast. Traditional industries on the weald expanded through to the end of the eighteenth centuries, with iron production blossoming.

Finds from the post-medieval period in general are very frequent with thousands of buckles recovered from fields across the county, more than the numbers seen in the medieval period. Other clothes fittings were also increasingly being made of metal in this period: sword belt fittings and hooked and eye clothes fasteners are also notably common. The majority of silver coinage reported is also from this period as silver was the primary monetary material until the reign of Charles II in the mid-seventeenth century. We also see more and more imported material from the post-medieval period as the world opened up during the Industrial Revolution and the growth of world trade.

The defence of Kent and by extension England was key to the development of the county during both the post-medieval and modern periods. Various phases of defensive works were carried out starting with Henry VIIIs forts at Walmer, Deal and Sandown. During the seventeenth century defences were built and refortified to face off against the resurgent

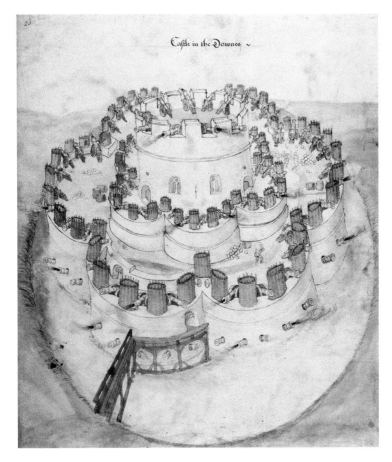

The original plan of Deal Fort as presented to Henry VIII in 1539. It diverges extensively in design form earlier fortifications (CO-o Anonymous).

Dutch, particularly after their notorious raid on Medway in June 1667. There was a lull in the early eighteenth century followed by new modern defences being constructed at a number of established forts from 1755, particularly at Dover with new defences at the castle, harbour and Western Heights. This building continued during the Napoleonic era and nineteenth century with the iconic Martello Towers along the coast and the Royal Military Canal between Seabrook and Cliff End dating to this period. Many of these historic defences were refortified during both world wars. Consequently, military objects and munitions, from sword fittings and cap badges to musket balls and unexploded bombs, are common stray finds in the county.

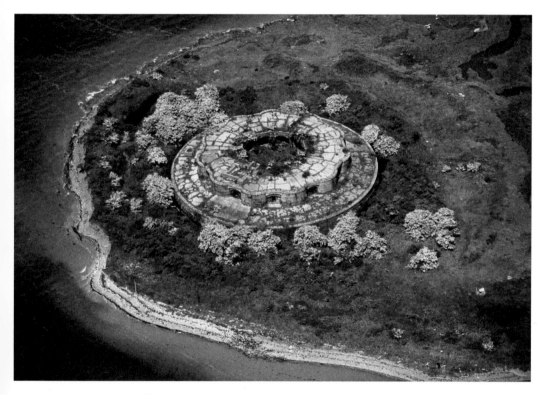

Hoo Fort in the Medway Estuary. Despite a 300-year gap with Henry's forts in east Kent they share similar design cues. Both are low to the ground compared to early fortifications, based on concentric circles and provide multi-level and multi-directional fields of fire. (© Kent County Council)

45. Copper-alloy buckle and leather strap (KENT-739D20)
Early post-medieval (1500–1650)
Found in Hothfield parish in 2019
50.59 mm

This buckle is of a type widely used from the medieval period to *c.* 1650, the projecting strap bar indicating that this example is certainly post-medieval. Double loop buckles became the predominant style of buckle in the post-medieval period, evolving over the seventeenth century to have separate spindles for the strap bar. Generally, the kind of sheet metal strap-bars common in the medieval period to attach buckles to their straps fell out of use. This particular buckle also retains a section of its leather belt or strap providing a perfect example of how they were attached to the buckle frame.

While copper is well known for inhibiting the microbiological decay of organic materials, the extent of survival in this case is still impressive especially as the local soil conditions are not conducive for the survival of organic remains.

The buckle survives in very good condition as does the strap. Note the projecting strap bar.

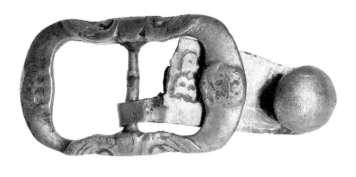

A later seventeenth century silver shoe buckle. The slight curvature would have fit the curvature of the foot. The fashion for separate strap bars first seen in the post-medieval buckles such as these becomes the norm by the eighteenth century. Found near Lenham (KENT-AA25B1).

A medieval buckle dating to *c.* 1200–1400, showing the kind of plates popular during the period but fallen out of use by the sixteenth century. Found near Cuxton (KENT-5E4EA9).

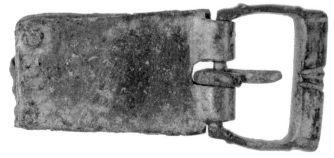

46. Copper-alloy skillet handle (KENT-4C5F3B)
Early post-medieval (1575–99)
Found near Dymchurch in 2018
125 mm

Fragments of slightly curved copper alloy, sometimes with evidence of a rim, are not uncommon finds in Kent and it can be tricky to narrowly date them. Most are likely to be from medieval or post-medieval cooking vessels. Certain fragments like feet or handles can help with identification as they are relatively distinctive between types. This kind of handle predominantly comes from skillets noted for their extended handles, deep bowls and tripod legs. This example, however, is also inscribed with the pious motto 'FEAR.GOD'. Such pious mottos are common on jewellery of the sixteenth and seventeenth century. The inscription continues with the makers name '+TAMAS.hACh'. Thomas Hatch is one of a number of foundry masters operating in Kent at the time, primarily at Broomfield.

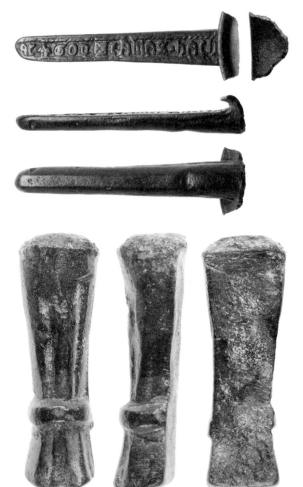

A skillet handle made by Thomas Hach. The inscription is very clear despite the beginning of the motto having been worn away by use.

A leg of a type typically found on types of skillets that Thomas Hatch would have produced. Found near Smeeth (KENT-4E48E5).

47. A silver vervel or hawking ring (KENT-4C5F3B)
Post-medieval (1626–77)
Found near Badlesmere in 2017
10.21 mm in diameter

This tiny silver ring was made to attach to the leather jesses or thongs on a falcon or hawk's legs, used to tether the bird to a block or leash. They tend to bear the name and place of residence of the owner of the hawk, to help return it to this owner should it be lost, much like bird ringing. This example is inscribed 'SR George Sondes Lees'. The Lees it refers to is the Lees Court estate where this vervel was found. The Sir George Sondes named on the vervel was 1st Earl of Faversham, who owned the estate during the middle quarters of the seventeenth century. This object is an unusually direct link to the past, as it is not often stray finds, even of this late date, can be directly linked to a historical figure. Even more unusually we know what Sir George looked like thanks to a portrait still owned by the estate. These connection also allowed the return of the vervel to Sir George's family at the estate.

Above: Sir George Sondes' vervel, though very worn. Its inscription is still relatively clear and hopefully the hawk it belonged to would have been brought swiftly home if lost.

Right: The portrait of Sir George Sondes dating to the mid-seventeenth century. Reproduced by kind permission of the Countess Sondes. (© Lees Court Estate)

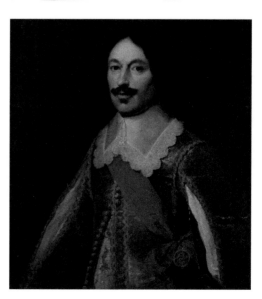

48. A gold memento mori ring (KENT-03BF25)
Seventeenth century (c. 1668)
Found in Godmersham in 2017
24.23 mm in length

Gold rings of medieval or post-medieval date are by far the most commonly reported treasure cases from Kent. Rings are easily lost, hidden or in some cases discarded. The two most common rings reported are the posie and mourning rings of the sixteenth to early eighteenth centuries. These rings tend to be related by the use of an internal inscription with some overlap particularly in the use of pious or romantic mottos and sayings. Dating has traditionally been based on lettering with block capitals popular during the sixteenth to early seventeenth century, lower case coming into use in the late sixteenth and becoming progressively more cursive until the eighteenth century. Bright enamel is a feature of posies around the late sixteenth to mid-seventeenth century, with darker enamels continuing into the eighteenth century on memento moris like this example.

Memento mori rings were to commemorate the passing of a loved one (Memento Mori translates as 'Memory of Death'). This example has the common skulls motif on the outer band, in ¾ profile, the skull would have been picked out in black enamel or niello and is a common motif on such rings. The inner band has the inscription 'In memoriam I B: 23 Junii 68'. The date and initials match the passing of Jane Brodnax in 1668, who was a resident of the country estate where the ring was found.

The memento mori ring commemorating Jane Brodnax, now on display at Godmersham Park Heritage Centre.

A gold posie with enamelled folate decoration around the band, now mostly worn away. Inscription 'give it thee, to thinke on mee R'. Found in Strood (KENT-6E645C).

49. A gold 1/2 escudo (KENT-03BF25)
Eighteenth century, dated 1733
Found in the parish of Hadlow in 2017
17 mm in diameter

Continental coinage circulating in Kent has never been particularly unusual, the close links and important trade hubs providing plenty of opportunities for its loss. With the development of European colonialism in the seventeenth and eighteenth century, we begin to regularly see coinage from much further afield. There is a particularly high number of coins from the Portuguese and Spanish colonies in Central and South America. Maritime trade, war booty and possibly even piracy/privateering help to account for the presence of such coinage. This is a particularly fine example of a milled (machine made) gold 1/2 escudo (800 Reis) of João V of Portugal. The M under the bust indicates it was produced at one of the colonial Brazilian mints in Rio, Bahia or Minas Gerais.

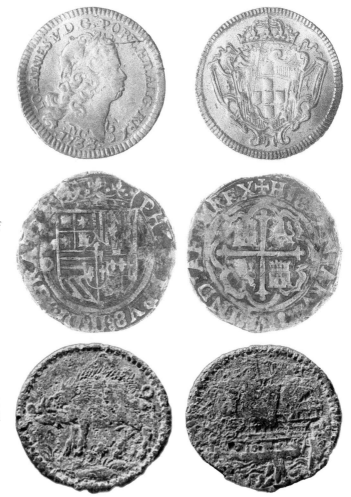

1/2 escudo of João V of Portugal.

A colonial cob silver reale of Philip II of Spain (1556–98), minted at Mexico City. Numerous coins like this were taken from Spanish ships during the sixteenth century. Found in Penhurst (KENT-C00F04).

A rare example of a colonial English coinage being found in Britain. Coins from Barbados such as this are known as 'hogge penny'. Found near Hawkinge (KENT-9E6E7D).

50. A coppered and silver badge (KENT-2DFFD2)
Early twentieth century (1914–18)
Found near East Malling in 2018
24.09 mm in length

While munitions predominate the military related finds of the later post-medieval and early modern period, the other significant group are regimental insignia through uniform buttons, cap badges and other uniform fittings. These objects are common stray finds and it is not usually possible to record them all. An exception is, however, made for those that have significant local connections like this particular badge.

The badge is made of cast sterling silver and decorated with an incised motif, the rearing horse of Kent on an oval plaque between scrolls, above and below. The county motto 'Invicta' is incised in the lower scroll and the initials K.V.F. in the upper. This is all within a large cast silver wreath. This central design is a direct match for the cap badge worn by the Kent Volunteer Fencibles, a First World War para-military force formed to protect Kent. This force effectively functioned like the Second World War's Homeguard and was based on a militia formation active during the Napoleonic era. The fencibles were eventually amalgamated into the regular Kentish regiments the Buffs and the West Kent's. While this item is clearly mimicking the official cap badges of the K.V.F, the wreath is not consistent with the design and neither is the pin fixing, which is typical of early twentieth-century civilian badges. It is therefore likely a personal commemorative piece for someone who served with a K.V.F battalion.

Commemorative badge of the Kent Volunteer Fencibles.

A Kent Volunteer Fencibles cap badge.